M000118631

THIS JOURNAL BELONGS TO:

..

"You can have anything
you want in life
if you dress for it."

...........

EDITH HEAD

ABRAMS NOTERIE, NEW YORK

THE MET

On the cover:

Dress by **Yves Saint Laurent**
YVES SAINT LAURENT
French, Fall/winter 1965–1966
Gift of Mrs. William Rand, 1969
C.I.69.23

All works are from the collection of The Metropolitan Museum of Art.

Design by Hana Anouk Nakamura
Illustrations by Judith van den Hoek

ISBN: 978-1-4197-2678-1

Printed and bound in China
10 9 8 7 6 5 4 3 2 1

Abrams Noterie products are available at special discounts when purchased
in quantity for premiums and promotions as well as fundraising or educational
use. Special editions can also be created to specification. For details, contact
specialsales@abramsbooks.com or the address below.

ABRAMS The Art of Books
115 West 18th Street, New York, NY 10011
abramsbooks.com

JANUARY | 1

Robe à la Polonaise
British, ca. 1780
Purchase, Gifts from Various Donors, 1998
1998.314a, b

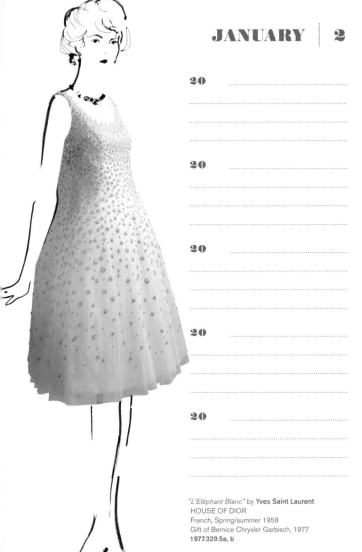

JANUARY | 2

20 ..
..
..
..

20 ..
..
..
..

20 ..
..
..
..

20 ..
..
..
..

20 ..
..
..
..

"L'Eléphant Blanc" by **Yves Saint Laurent**
HOUSE OF DIOR
French, Spring/summer 1958
Gift of Bernice Chrysler Garbisch, 1977
1977.329.5a, b

JANUARY | 3

20 ..
..
..

20 ..
..
..

20 ..
..
..

20 ..
..
..

20 ..
..
..

Dress
American, 1902–1904
Gift of Mrs. Oscar de la Renta, 1994
1994.192.18a–c

20

..............................
..............................
..............................

20

..............................
..............................
..............................

20

..............................
..............................
..............................

20

..............................
..............................
..............................

20

..............................
..............................
..............................

Round gown
British, ca. 1798
Purchase, Gifts from Various Donors, 1998
1998.222.1

JANUARY | 5

20 ..
..
..
..

20 ..
..
..
..

20 ..
..
..
..

20 ..
..
..
..

20 ..
..
..
..

Dress attributed to **Yves Saint Laurent**
YVES SAINT LAURENT
French, ca. 1965
Brooklyn Museum Costume Collection at The Metropolitan Museum of Art,
Gift of the Brooklyn Museum, 2009; Gift of Jane Holzer, 1977
2009.300.526

20 ... 20 ...

... ...

... ...

... ...

20 ... 20 ...

... ...

... ...

... ...

20 ... *Ensemble* (detail)
Probably European, ca. 1798
... Purchase, Irene Lewisohn and Alice L. Crowley
Bequests, 1992
... **1992.119.1a–c**

...

...

JANUARY | 7

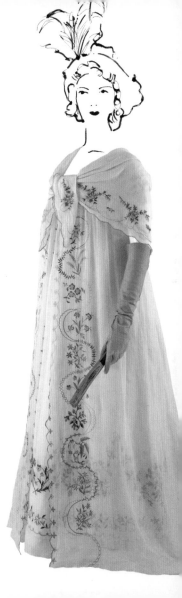

20 ...
...
...
...

20 ...
...
...
...

20 ...
...
...
...

20 ...
...
...
...

20 ...
...
...
...

Ensemble
Probably European, ca. 1798
Purchase, Irene Lewisohn and Alice L. Crowley
Bequests, 1992
1992.119.1a–c

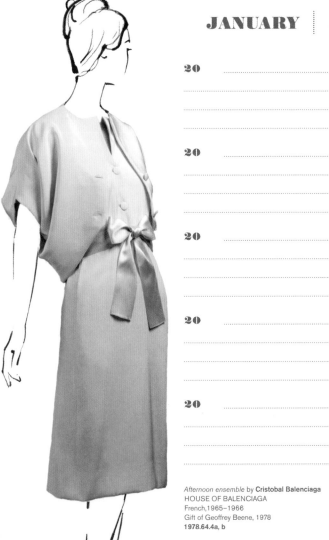

20
....................................
....................................
....................................

20
....................................
....................................
....................................

20
....................................
....................................
....................................

20
....................................
....................................
....................................

20
....................................
....................................
....................................

Afternoon ensemble by **Cristobal Balenciaga**
HOUSE OF BALENCIAGA
French, 1965–1966
Gift of Geoffrey Beene, 1978
1978.64.4a, b

20

20

20

20

20

Evening slippers
American, ca. 1898
Brooklyn Museum Costume Collection at
The Metropolitan Museum of Art, Gift of the
Brooklyn Museum, 2009; Anonymous gift, 1937
2009.300.1425a, b

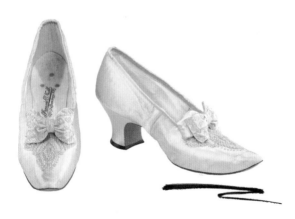

20

20

20

20

20

Hat by **Halston**
American, ca. 1965
Brooklyn Museum Costume Collection at
The Metropolitan Museum of Art, Gift of the Brooklyn
Museum, 2009; Gift of Virginia Inness-Brown, 1986
2009.300.2636

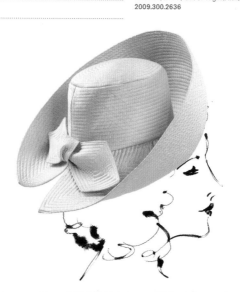

JANUARY | 11

20 ...
...
...
...

20 ...
...
...
...

20 ...
...
...
...

20 ...
...
...
...

20 ...
...
...
...

20

20

20

20

20

Suit by **Gabrielle "Coco" Chanel**
HOUSE OF CHANEL
French, 1963–1968
Gift of Mrs. Lyn Revson, 1975
1975.53.7a–e

JANUARY | 13

20 ..
..
..

20 ..
..
..

20 ..
..
..

20 ..
..
..

20 ..
..
..

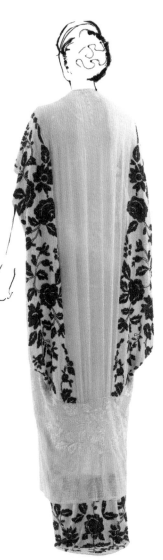

Evening coat
French, 1918–1920
Isabel Shults Fund, 2001
2001.374.1

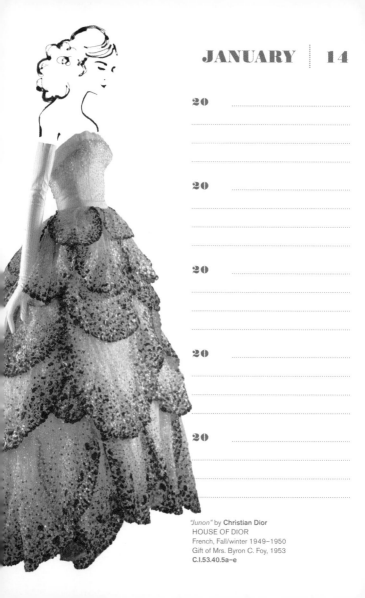

20

..........................

..........................

..........................

20

..........................

..........................

..........................

20

..........................

..........................

..........................

20

..........................

..........................

..........................

20

..........................

..........................

..........................

"Junon" by **Christian Dior**
HOUSE OF DIOR
French, Fall/winter 1949–1950
Gift of Mrs. Byron C. Foy, 1953
C.I.53.40.5a–e

JANUARY | 15

20 ..

20 ..
..
..
..

20 ..
..
..
..

20 ..
..
..

20 ..
..
..
..

20 ..
..
..

"Junon" (detail) by **Christian Dior**
HOUSE OF DIOR
French, Fall/winter 1949–1950
Gift of Mrs. Byron C. Foy, 1953
C.I.53.40.5a–e

20

20

20

20

20

Shoes by **C. Nannelli**
Brooklyn Museum Costume Collection at
The Metropolitan Museum of Art, Gift of the Brooklyn
Museum, 2009; Gift of Charline Osgood, 1960
2009.300.3810a, b

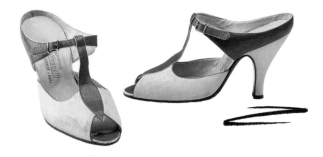

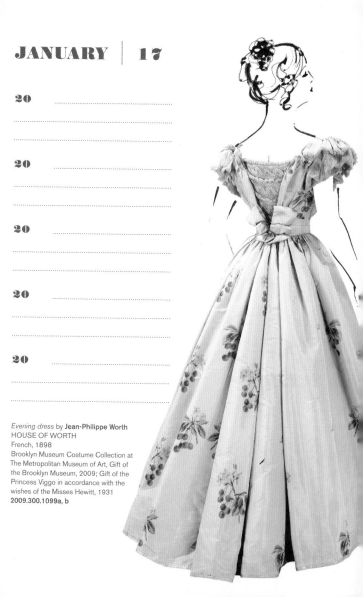

20

20

20

20

20

Evening dress by **Jean-Philippe Worth**
HOUSE OF WORTH
French, 1898
Brooklyn Museum Costume Collection at
The Metropolitan Museum of Art, Gift of
the Brooklyn Museum, 2009; Gift of the
Princess Viggo in accordance with the
wishes of the Misses Hewitt, 1931
2009.300.1099a, b

JANUARY | 18

20
.......................................
.......................................
.......................................

20
.......................................
.......................................
.......................................

20
.......................................
.......................................
.......................................

20
.......................................
.......................................
.......................................

20
.......................................
.......................................
.......................................

Dinner dress
British, 1824–1826
Purchase, Irene Lewisohn Bequest, 2015
2015.98a, b

20 ..

20 ..

20 ..

20 ..

20 ..

Dinner dress (detail)
British, 1824–1826
Purchase, Irene Lewisohn Bequest, 2015
2015.98a, b

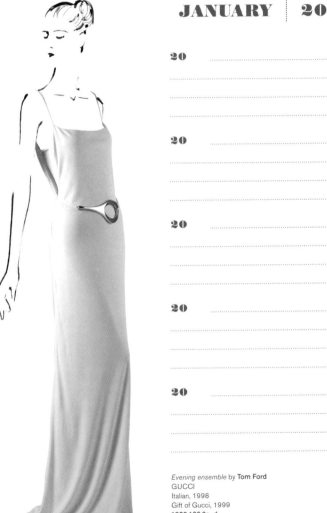

20

..
..
..
..

20

..
..
..
..

20

..
..
..
..

20

..
..
..
..

20

..
..
..
..

Evening ensemble by **Tom Ford**
GUCCI
Italian, 1998
Gift of Gucci, 1999
1999.136.2a–d

20 ..

..

..

20 ..

..

..

20 ..

..

..

20 ..

..

..

20 ..

..

..

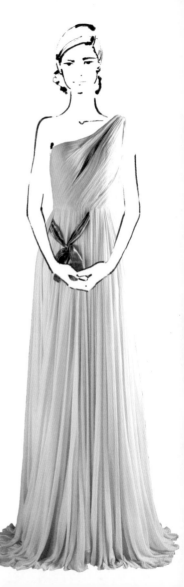

Evening dress by **Madame Grès (Alix Barton)**
French, Fall/winter 1954–1955
Gift of Mrs. Byron C. Foy, 1956
C.I.56.60.6a, b

20

..
..
..
..

20

..
..
..
..

20

..
..
..
..

20

..
..
..
..

20

..
..
..
..

"White Stealth"
BOUDICCA
British, Fall/winter 2006–2007
Purchase, The Dorothy Strelsin Foundation Inc.
Gift, 2006
2006.198a–i

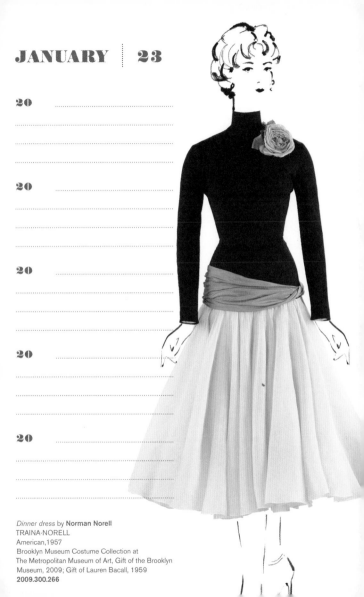

20 ..

20 ..

20 ..

20 ..

20 ..

Dinner dress by **Norman Norell**
TRAINA-NORELL
American,1957
Brooklyn Museum Costume Collection at
The Metropolitan Museum of Art, Gift of the Brooklyn
Museum, 2009; Gift of Lauren Bacall, 1959
2009.300.266

20

...............................

...............................

...............................

...............................

20

...............................

...............................

...............................

...............................

20

...............................

...............................

...............................

...............................

20

...............................

...............................

...............................

...............................

20

...............................

...............................

...............................

...............................

Dress by **Mme. Eta Hentz**
American, Spring/summer 1944
Brooklyn Museum Costume Collection at
The Metropolitan Museum of Art, Gift of the Brooklyn
Museum, 2009; Gift of Madame Eta Hentz, 1946
2009.300.118a–c

JANUARY | 25

20 ...
...

20 ...
...

20 ...
...

20 ...
...

20 ...
...
...

"Clover Leaf" by **Charles James**
American, 1953
Brooklyn Museum Costume Collection at
The Metropolitan Museum of Art, Gift of the Brooklyn
Museum, 2009; Gift of Mrs. Cornelius V. Whitney, 1953
2009.300.779

20 ...
...
...
...

20 ...
...
...
...

20 ...
...
...
...

20 ...
...
...
...

20 ...
...
...
...

Wedding dress by **Bonnie Cashin**
American, 1953
Brooklyn Museum Costume Collection at
The Metropolitan Museum of Art, Gift of the Brooklyn
Museum, 2009; Gift of Bonnie Cashin, 1953
2009.300.8a, b

20

20

20

20

20

Pumps
FONTANA
Italian, 1956
Brooklyn Museum Costume Collection at
The Metropolitan Museum of Art, Gift of the Brooklyn
Museum, 2009; Gift of Charline Osgood, 1960
2009.300.3795a, b

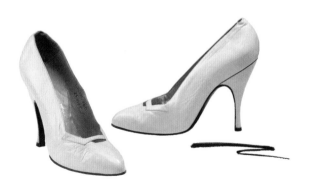

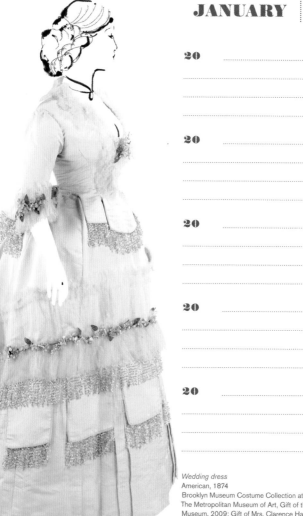

JANUARY | 28

20

....................
....................
....................
....................

20

....................
....................
....................
....................

20

....................
....................
....................
....................

20

....................
....................
....................
....................

20

....................
....................
....................
....................

Wedding dress
American, 1874
Brooklyn Museum Costume Collection at
The Metropolitan Museum of Art, Gift of the Brooklyn
Museum, 2009; Gift of Mrs. Clarence Hand, 1972
2009.300.3879a, b

JANUARY | 29

20 .. 20 ..

.. ..

.. ..

20 .. 20 ..

.. ..

.. ..

20 ..

.. *Evening shoes*
French, 1875–1885
.. Brooklyn Museum Costume Collection at
The Metropolitan Museum of Art,
.. Gift of the Brooklyn Museum, 2009;
Gift of Mrs. Frederick H. Prince, Jr., 1967
2009.300.1581a, b

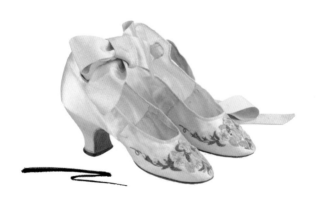

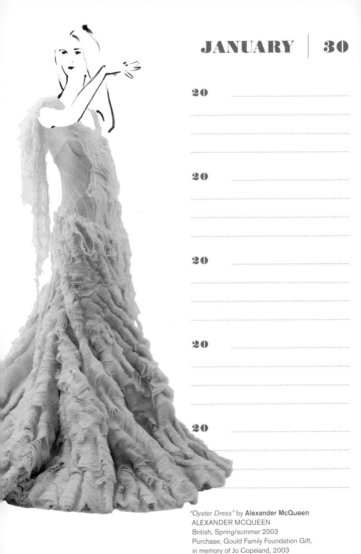

20 ..
 ..
 ..
 ..

20 ..
 ..
 ..
 ..

20 ..
 ..
 ..
 ..

20 ..
 ..
 ..
 ..

20 ..
 ..
 ..
 ..

"Oyster Dress" by **Alexander McQueen**
ALEXANDER MCQUEEN
British, Spring/summer 2003
Purchase, Gould Family Foundation Gift,
in memory of Jo Copeland, 2003
2003.462

JANUARY | 31

20 ..
..
..
..

20 ..
..
..
..

20 ..
..
..
..

20 ..
..
..
..

20 ..
..
..
..

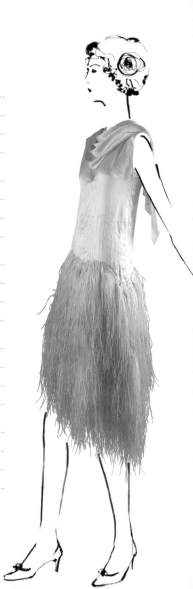

Evening dress by **Louiseboulanger**
French, 1928
Gift of Mrs. Wolcott Blair, 1973
1973.6a, b

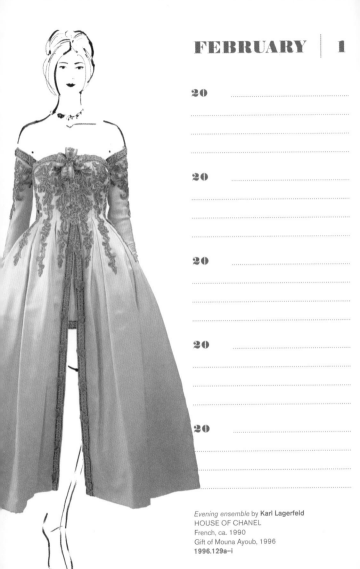

FEBRUARY | 1

20
...............................
...............................
...............................

20
...............................
...............................
...............................

20
...............................
...............................
...............................

20
...............................
...............................
...............................

20
...............................
...............................
...............................

Evening ensemble by **Karl Lagerfeld**
HOUSE OF CHANEL
French, ca. 1990
Gift of Mouna Ayoub, 1996
1996.129a–i

FEBRUARY | 2

20

20

20

20

20

Dinner ensemble (shoes) by **Dupuis-Jacobs**
French, 1874
Brooklyn Museum Costume Collection at
The Metropolitan Museum of Art, Gift of the Brooklyn
Museum, 2009; Gift of Mrs. Arthur L. Swift, 1962
2009.300.862c, d

20 ...
...
...
...

20 ...
...
...
...

20 ...
...
...
...

20 ...
...
...
...

20 ...
...
...
...

Dress by **Hubert de Givenchy**
HOUSE OF GIVENCHY
French, 1953
Brooklyn Museum Costume Collection at
The Metropolitan Museum of Art, Gift of the Brooklyn
Museum, 2009; Gift of Lauren Bacall, 1967
2009.300.913a, b

FEBRUARY | 4

20

20

20

20

20

Ball gown by **Catherine Walker**
British, 1989
Gift of Mrs. Randolph Hearst, 1998
1998.219

FEBRUARY | 5

20

20

20

20

20

"May" by **Christian Dior**
HOUSE OF DIOR
French, Spring/summer 1953
Gift of Mrs. David Kluger, 1960
C.I.60.21.1a, b

FEBRUARY | 6

20 ...

20 ...

20 ...

20 ...

20 ...

20 ...

"May" (detail) by **Christian Dior**
HOUSE OF DIOR
French, Spring/summer 1953
Gift of Mrs. David Kluger, 1960
C.I.60.21.1a, b

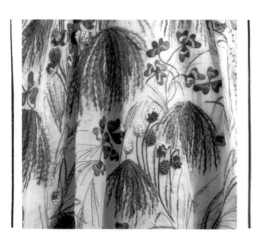

20

...
...
...

20

...
...
...

20

...
...
...

20

...
...
...

20

...
...
...

Robe à la Française
British, 1740s
Harris Brisbane Dick Fund, 1995
1995.235a, b

FEBRUARY | 8

20

20

20

20

20

Evening slippers by **Gundry & Sons**
British, 1840–1849
Brooklyn Museum Costume Collection at
The Metropolitan Museum of Art, Gift of the Brooklyn
Museum, 2009; Gift of Herman Delman, 1954
2009.300.1463a, b

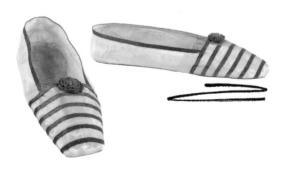

20

20

20

20

20

Promenade dress
American, 1862–1864
Gift of Chauncey Stillman, 1960
C.I.60.6.11a, b

FEBRUARY | 10

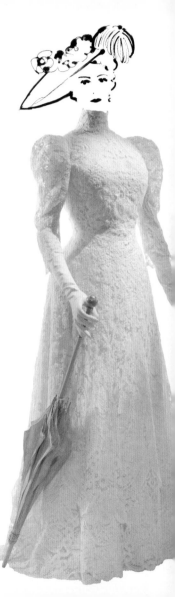

20 ...
...
...
...

20 ...
...
...
...

20 ...
...
...
...

20 ...
...
...
...

20 ...
...
...
...

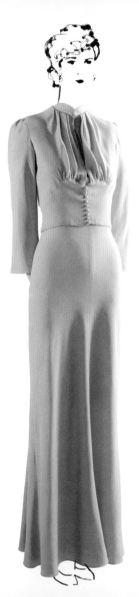

FEBRUARY | 11

20
..
..
..
..

20
..
..
..
..

20
..
..
..
..

20
..
..
..
..

20
..
..
..
..

Wedding ensemble by **Mainbocher**
American, 1937
Gift of the Duchess of Windsor, 1950
C.I.50.110a–j

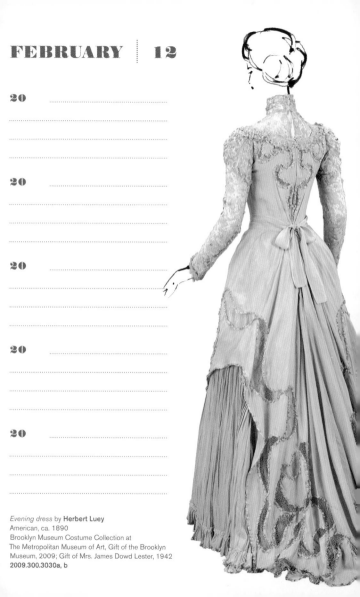

FEBRUARY | 12

20 ...
...
...

20 ...
...
...

20 ...
...
...

20 ...
...
...

20 ...
...
...

Evening dress by **Herbert Luey**
American, ca. 1890
Brooklyn Museum Costume Collection at
The Metropolitan Museum of Art, Gift of the Brooklyn
Museum, 2009; Gift of Mrs. James Dowd Lester, 1942
2009.300.3030a, b

20 ...

20 ...

20 ...

20 ...

20 ...

Evening dress (detail) by **Callot Soeurs**
French, 1910–1914
The Jacqueline Loewe Fowler Costume Collection,
Gift of Jacqueline Loewe Fowler, 1981
1981.380.2

FEBRUARY | 14

20

..
..
..

20

..
..
..

20

..
..
..

20

..
..
..

20

..
..
..

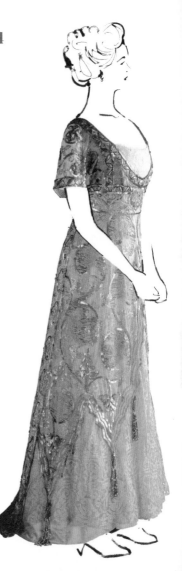

Evening dress by **Callot Soeurs**
French, 1910–1914
The Jacqueline Loewe Fowler Costume Collection,
Gift of Jacqueline Loewe Fowler, 1981
1981.380.2

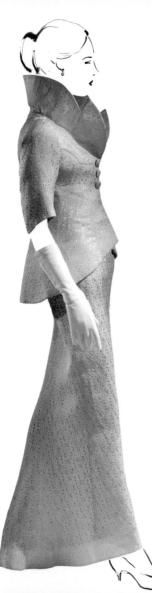

20

.....................................
.....................................
.....................................
.....................................

20

.....................................
.....................................
.....................................
.....................................

20

.....................................
.....................................
.....................................
.....................................

20

.....................................
.....................................
.....................................
.....................................

20

.....................................
.....................................
.....................................
.....................................

Dinner suit by **Charles James**
American, 1956
Brooklyn Museum Costume Collection at
The Metropolitan Museum of Art, Gift of the Brooklyn
Museum, 2009; Gift of Mrs. John de Menil, 1957
2009.300.824a, b

FEBRUARY | 16

20

..

..

..

20

..

..

..

20

..

..

20

..

..

..

20

..

..

..

Evening shoes by **Roger Vivier**
HOUSE OF DIOR
French, 1954
Gift of Valerian Stux-Rybar, 1980
1980.597.14

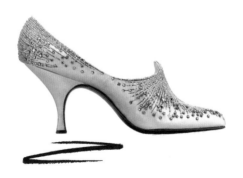

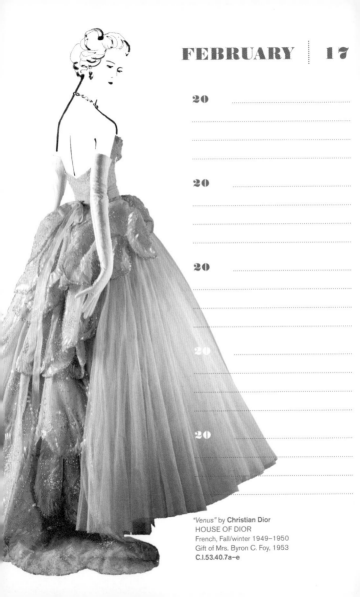

20

20

20

20

20

"Venus" by **Christian Dior**
HOUSE OF DIOR
French, Fall/winter 1949–1950
Gift of Mrs. Byron C. Foy, 1953
C.I.53.40.7a–e

FEBRUARY | 18

20 ..

20 ..

20 ..

20 ..

20 ..

"Venus" (detail) by **Christian Dior**
HOUSE OF DIOR
French, Fall/winter 1949–1950
Gift of Mrs. Byron C. Foy, 1953
C.I.53.40.7a–e

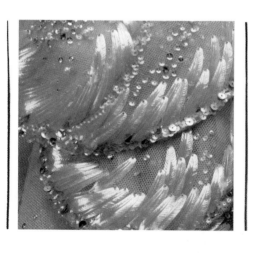

20

......................................

......................................

......................................

20

......................................

......................................

......................................

20

......................................

......................................

......................................

20

......................................

......................................

......................................

20

......................................

......................................

Shoes by **Tokio Kumagaï**
Japanese, Late 1980s
Gift of Jamee Gregory, 2005
2005.322.12a, b

FEBRUARY | 20

20

20

20

20

20

Evening slippers by **L. Perchellet**
French, 1890–1899
Brooklyn Museum Costume Collection at
The Metropolitan Museum of Art, Gift of the Brooklyn
Museum, 2009; Gift of Rodman A. Heeren, 1959
2009.300.1523a, b

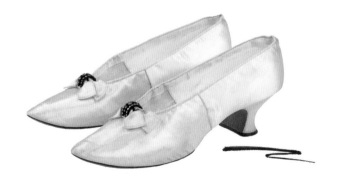

20

20

20

20

20

Dinner dress by **Alice M. Dunstan**
American, ca. 1895
Purchase, Irene Lewisohn Bequest, 1981
1981.21.2a, b

20 ..

..

..

..

20 ..

..

..

..

20 ..

..

..

..

20 ..

..

..

..

20 ..

..

..

..

Evening boots
French, 1860–1869
Brooklyn Museum Costume Collection at
The Metropolitan Museum of Art, Gift of the Brooklyn
Museum, 2009; Gift of Mrs. G. Brinton Roberts, 1946
2009.300.1439a–d

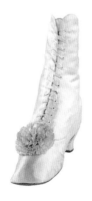
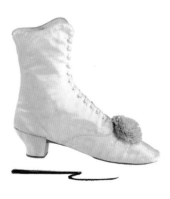

20

20

20

20

20

Dress by **Christian Francis Roth**
American, 1989
Gift of Amy Fine Collins, 1993
1993.510.4

FEBRUARY | 24

20 ... **20** ...

...

...

...

20 ... **20** ...

...

...

...

Morning cap **20** ...
American, ca. 1830
Brooklyn Museum Costume Collection at
The Metropolitan Museum of Art, Gift of the Brooklyn
Museum, 2009; Gift of Mrs. Alvah E. Reed, 1966
2009.300.2881

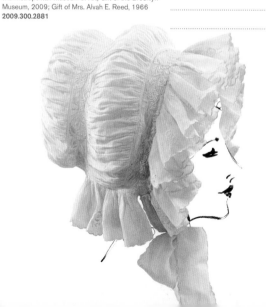

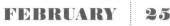

FEBRUARY | 25

20 ...
...
...
...

20 ...
...
...
...

20 ...
...
...
...

20 ...
...
...
...

20 ...
...
...
...

Evening dress by **George Peter Stavropoulos**
American, ca. 1972
Brooklyn Museum Costume Collection at
The Metropolitan Museum of Art, Gift of the Brooklyn
Museum, 2009; Gift of Mildred Custin, 1975
2009.300.2913

FEBRUARY | 26

20

......................................

......................................

20

......................................

......................................

20

......................................

......................................

20

......................................

......................................

20

......................................

......................................

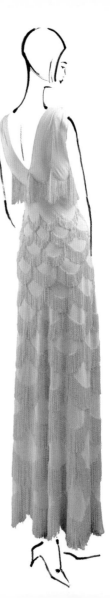

Evening dress by **Madeleine Vionnet**
French, Spring/summer 1938
Gift of Madame Madeleine Vionnet, 1952
C.I.52.18.4

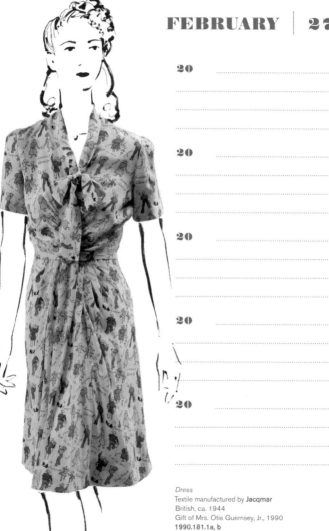

20

20

20

20

20

Dress
Textile manufactured by **Jacqmar**
British, ca. 1944
Gift of Mrs. Otis Guernsey, Jr., 1990
1990.181.1a, b

FEBRUARY | 28

20

..

..

..

20

..

..

..

20

..

..

..

20

..

..

..

20

..

..

..

Pumps
Spanish, ca. 1956
Brooklyn Museum Costume Collection at
The Metropolitan Museum of Art, Gift of the Brooklyn
Museum, 2009; Gift of Margaret Jerrold Inc., 1965
2009.300.3844a, b

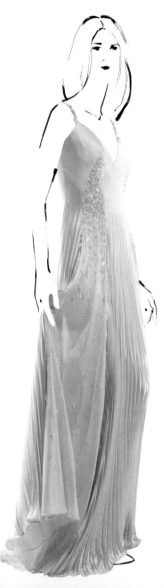

20

20

20

20

20

Evening dress by **Gianni Versace**
GIANNI VERSACE
Italian, Spring/summer 1996
Gift of Donatella Versace, 1999
1999.328.4

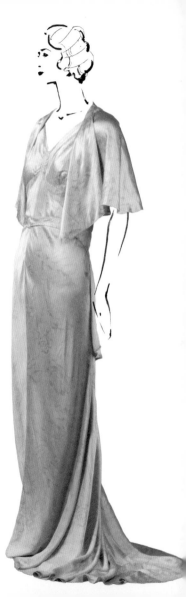

MARCH | 1

20

20

20

20

20

Evening ensemble by **Jean Patou**
HOUSE OF PATOU
French, ca. 1931
Gift of Madame Lilliana Teruzzi, 1972
1972.30.17a, b

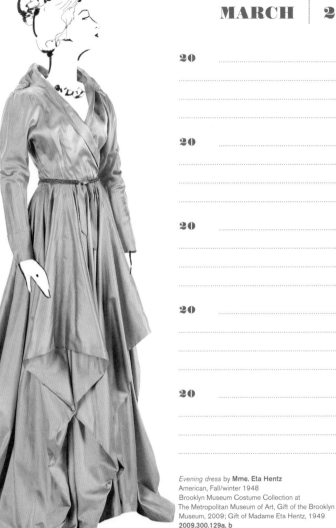

20

20

20

20

20

Evening dress by **Mme. Eta Hentz**
American, Fall/winter 1948
Brooklyn Museum Costume Collection at
The Metropolitan Museum of Art, Gift of the Brooklyn
Museum, 2009; Gift of Madame Eta Hentz, 1949
2009.300.129a, b

MARCH | 3

20

20

20

20

20

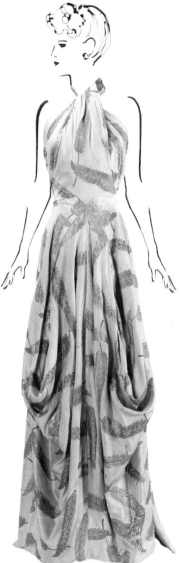

Evening dress by **Charles James**
American, 1946
Brooklyn Museum Costume Collection at
The Metropolitan Museum of Art, Gift of the Brooklyn
Museum, 2009; Gift of Mrs. Harrison Williams, 1948
2009.300.687

MARCH | 4

20

20

20

20

20

Evening dress by **Elsa Schiaparelli**
HOUSE OF LESAGE
French, Fall 1939
Brooklyn Museum Costume Collection at
The Metropolitan Museum of Art, Gift of the Brooklyn
Museum, 2009; Gift of Millicent Huttleston Rogers, 19
2009.300.1165a, b

MARCH | 5

Evening dress (detail) by **Elsa Schiaparelli**
HOUSE OF LESAGE
French, Fall 1939
Brooklyn Museum Costume Collection at
The Metropolitan Museum of Art, Gift of the Brooklyn
Museum, 2009; Gift of Millicent Huttleston
Rogers, 1951
2009.300.1165a, b

20

.......................................
.......................................
.......................................
.......................................

20

.......................................
.......................................
.......................................
.......................................

20

.......................................
.......................................
.......................................
.......................................

20

.......................................
.......................................
.......................................
.......................................

20

.......................................
.......................................
.......................................
.......................................

"Remote Control" by **Hussein Chalayan**
British, Spring/summer 2000, edition 2005
Purchase, Friends of The Costume Institute Gifts, 2006
2006.251a–c

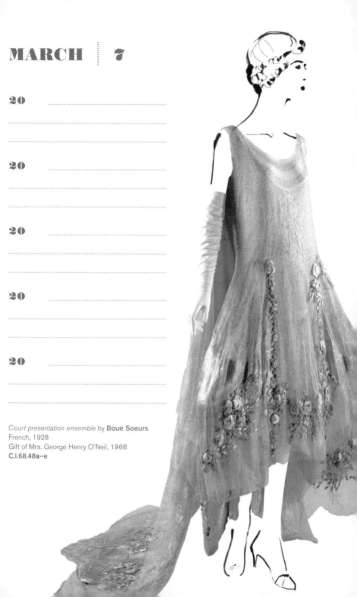

MARCH | 7

20 ...

..

..

20 ...

..

..

20 ...

..

..

20 ...

..

..

20 ...

..

..

Court presentation ensemble by **Boué Soeurs**
French, 1928
Gift of Mrs. George Henry O'Neil, 1968
C.I.68.48a–e

20

...

...

...

20

...

...

...

20

...

...

...

20

...

...

...

20

...

...

...

Tea gown
LIBERTY & CO.
British, ca. 1885
Brooklyn Museum Costume Collection at
The Metropolitan Museum of Art, Gift of the Brooklyn
Museum, 2009; Designated Purchase Fund, 1986
2009.300.3384

MARCH | 9

20 ..

20 ..

20 ..

20 ..

20 ..

20 ..

Cap
American, ca. 1900
Brooklyn Museum Costume Collection at
The Metropolitan Museum of Art, Gift of the Brooklyn
Museum, 2009; Gift of Mrs. Robert G. Olmsted and
Constable MacCracken, 1969
2009.300.2901

20

20

20

20

20

Boots
CHARLES STROHBECK, INC.
American, ca. 1918
Brooklyn Museum Costume Collection at
The Metropolitan Museum of Art, Gift of the Brooklyn
Museum, 2009; Gift of Charles Strohbeck, 1964
2009.300.1552a–d

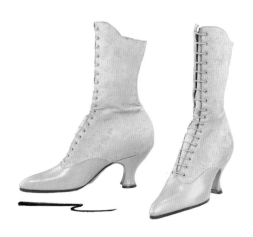

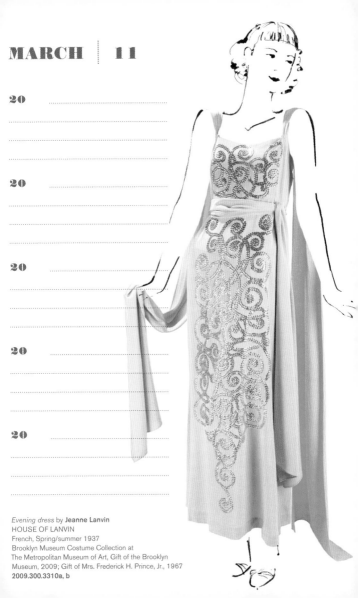

MARCH | 11

20

..

..

..

20

..

..

..

20

..

..

..

20

..

..

..

20

..

..

..

Evening dress by **Jeanne Lanvin**
HOUSE OF LANVIN
French, Spring/summer 1937
Brooklyn Museum Costume Collection at
The Metropolitan Museum of Art, Gift of the Brooklyn
Museum, 2009; Gift of Mrs. Frederick H. Prince, Jr., 1967
2009.300.3310a, b

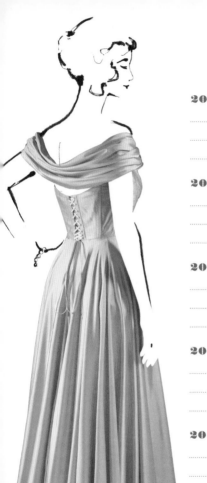

MARCH | 12

20

..

..

..

..

20

..

..

..

..

20

..

..

..

..

20

..

..

..

..

20

..

..

..

..

Evening dress by **Jacques Fath**
HOUSE OF JACQUES FATH
French, Spring/summer 1947
Gift of Richard Martin, 1993
1993.55

MARCH | 13

20 ..
..
..
..

20 ..
..
..
..

20 ..
..
..
..

20 ..
..
..
..

20 ..
..
..
..

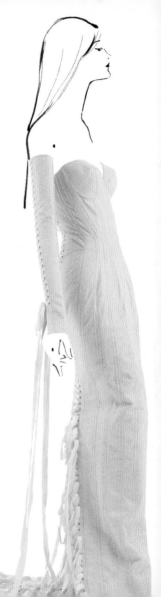

Evening ensemble by **Jean Paul Gaultier**
French, Spring/summer 2001
Purchase, Catharine Breyer Van Bomel Foundation
Gift, and funds from various donors, 2001
2001.455.2a–i

20

..

..

..

..

20

..

..

..

..

20

..

..

..

..

20

..

..

..

..

20

..

..

..

..

Robe à l'Anglaise
French, 1785–1787
Purchase, Irene Lewisohn Bequest, 1966
C.I.66.39a, b

MARCH | 15

20 ..
..
..

20 ..
..
..

20 ..
..
..

20 ..
..
..

20 ..
..
..

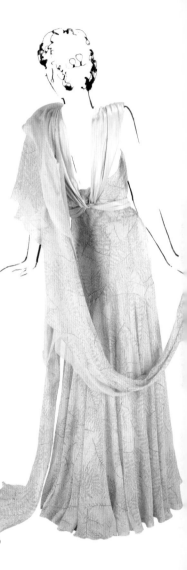

Evening ensemble by **Madeleine Vionnet**
French, ca. 1936
Brooklyn Museum Costume Collection at
The Metropolitan Museum of Art, Gift of the Brooklyn
Museum, 2009; Gift of Mrs. Edward G. Sparrow, 1969
2009.300.2583a–c

20

20

20

20

20

Evening slippers
HING SHENG BOOT AND SHOE MAKER
Probably American, 1855–1865
Brooklyn Museum Costume Collection at
The Metropolitan Museum of Art, Gift of the Brooklyn
Museum, 2009; Gift of Mrs. Alvah E. Reed, 1966
2009.300.1559a, b

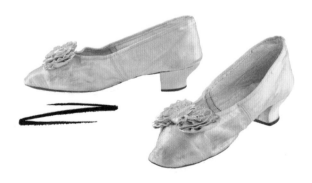

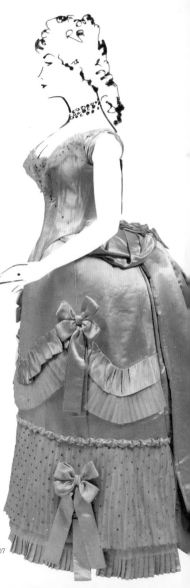

MARCH | 17

Court presentation ensemble (shown with bodice
component "c") by **Charles Frederick Worth**
HOUSE OF WORTH
French, ca. 1888
Purchase, Friends of The Costume Institute Gifts, 2007
2007.385a–l

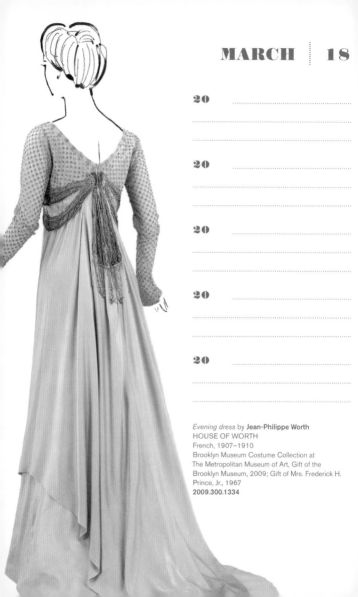

20 ...

...

...

20 ...

...

...

20 ...

...

...

20 ...

...

...

20 ...

...

...

Evening dress by **Jean-Philippe Worth**
HOUSE OF WORTH
French, 1907–1910
Brooklyn Museum Costume Collection at
The Metropolitan Museum of Art, Gift of the
Brooklyn Museum, 2009; Gift of Mrs. Frederick H.
Prince, Jr., 1967
2009.300.1334

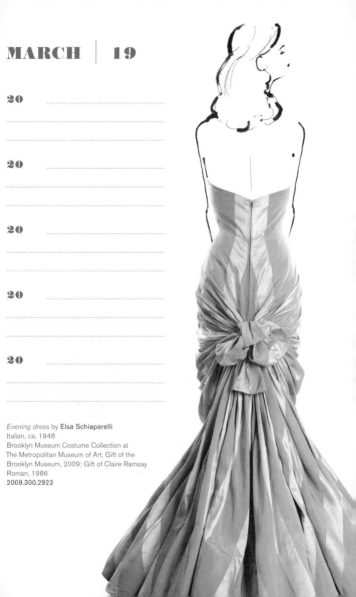

20

20

20

20

20

Evening dress by **Elsa Schiaparelli**
Italian, ca. 1948
Brooklyn Museum Costume Collection at
The Metropolitan Museum of Art, Gift of the
Brooklyn Museum, 2009; Gift of Claire Ramsay
Roman, 1986
2009.300.2923

20

20

20

20

20

20

Hat by **Elsa Schiaparelli**
Italian, Summer 1940
Brooklyn Museum Costume Collection at
The Metropolitan Museum of Art, Gift of the Brooklyn
Museum, 2009; Gift of Arturo and Paul Peralta-
Ramos, 1955
2009.300.1873

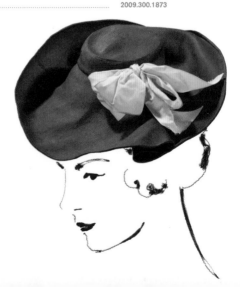

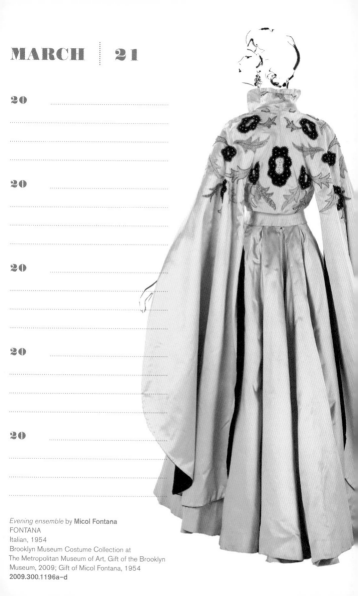

20 ..
..
..
..

20 ..
..
..
..

20 ..
..
..
..

20 ..
..
..
..

20 ..
..
..
..

Evening ensemble by **Micol Fontana**
FONTANA
Italian, 1954
Brooklyn Museum Costume Collection at
The Metropolitan Museum of Art, Gift of the Brooklyn
Museum, 2009; Gift of Micol Fontana, 1954
2009.300.1196a–d

20

.................................

.................................

.................................

.................................

20

.................................

.................................

.................................

.................................

20

.................................

.................................

.................................

.................................

20

.................................

.................................

.................................

.................................

20

.................................

.................................

.................................

.................................

Evening dress (detail) by **Hubert de Givenchy**
HOUSE OF GIVENCHY
French, Early 1960s
Gift of Mrs. John Hay Whitney, 1974
1974.184.1a–c

MARCH | 23

20

20

20

20

20

Evening dress by **Hubert de Givenchy**
HOUSE OF GIVENCHY
French, Early 1960s
Gift of Mrs. John Hay Whitney, 1974
1974.184.1a–c

20

20

20

20

20

Evening dress by **Sophie Gimbel**
American, 1955
Brooklyn Museum Costume Collection at
The Metropolitan Museum of Art, Gift of the Brooklyn
Museum, 2009; Gift of Sophie Gimbel, 1955
2009.300.2430a–c

MARCH | 25

Hat
BETTE AND LEE
American, ca. 1958
Brooklyn Museum Costume Collection at
The Metropolitan Museum of Art, Gift of the Brooklyn
Museum, 2009; Gift of Dorothy Haase, 1983
2009.300.2621a–c

20

20

20

20

20

Dress by **Gabrielle "Coco" Chanel**
HOUSE OF CHANEL
French, ca. 1924
Purchase, Irene Lewisohn Bequest, 1975
1975.7

MARCH | 27

20
..........
..........

20
..........
..........

20
..........
..........

20
..........
..........

20
..........
..........

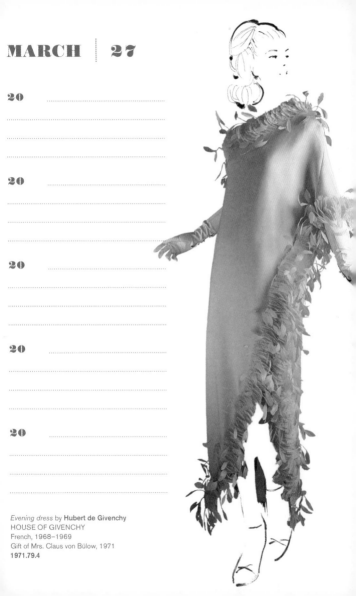

Evening dress by **Hubert de Givenchy**
HOUSE OF GIVENCHY
French, 1968–1969
Gift of Mrs. Claus von Bülow, 1971
1971.79.4

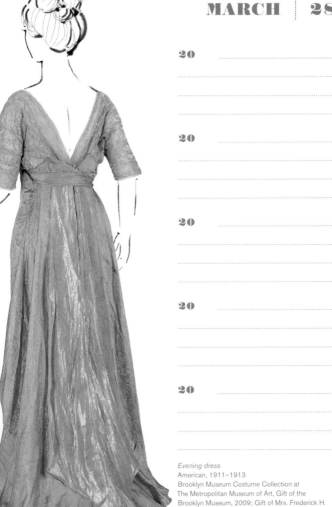

20

20

20

20

20

Evening dress
American, 1911–1913
Brooklyn Museum Costume Collection at
The Metropolitan Museum of Art, Gift of the
Brooklyn Museum, 2009; Gift of Mrs. Frederick H.
Prince, Jr., 1967
2009.300.3305

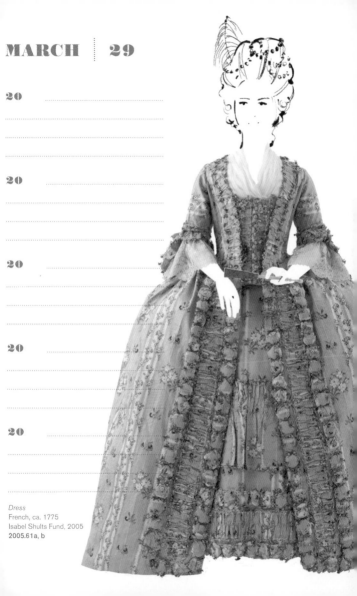

20

..................

..................

..................

20

..................

..................

..................

20

..................

..................

..................

20

..................

..................

..................

20

..................

..................

..................

Dress
French, ca. 1775
Isabel Shults Fund, 2005
2005.61a, b

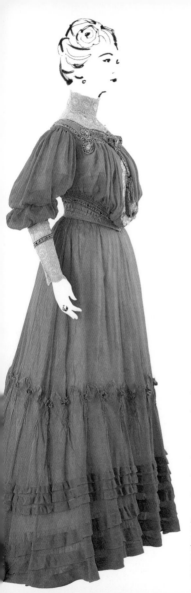

20 ...
...
...
...

20 ...
...
...
...

20 ...
...
...
...

20 ...
...
...
...

20 ...
...
...
...

Afternoon dress by **Jacques Doucet**
French, ca. 1903
Brooklyn Museum Costume Collection at
The Metropolitan Museum of Art, Gift of the Brooklyn
Museum, 2009; Gift of Orme and R. Thornton Wilson in
memory of Caroline Schermerhorn Astor Wilson, 1949
2009.300.1153a, b

MARCH | 31

20

...

...

...

20

...

...

...

20

...

...

...

20

...

...

...

20

...

...

...

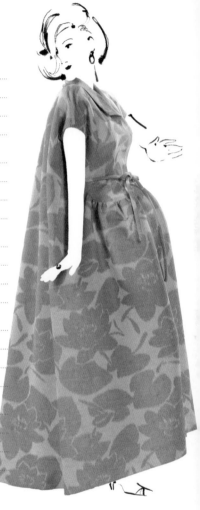

Evening dress by **Hubert de Givenchy**
HOUSE OF GIVENCHY
French, ca. 1963
Brooklyn Museum Costume Collection at The Metropolitan
Museum of Art, Gift of the Brooklyn Museum, 2009; Gift of
Mrs. Benjamin R. Kittredge, 1971
2009.300.492a, b

20

......................
......................
......................
......................

20

......................
......................
......................
......................

20

......................
......................
......................
......................

20

......................
......................
......................
......................

20

......................
......................
......................
......................

Evening dress by **James Galanos**
American, 1959–1961
Brooklyn Museum Costume Collection at
The Metropolitan Museum of Art, Gift of the Brooklyn
Museum, 2009; Gift of Mildred Morton, 1961
2009.300.2010

20

20

20

20

20

Dress by **Rudi Gernreich**
American, 1967–1968
Gift of Betty Furness, 1986
1986.517.17a, b

20

20

20

20

20

Dress by **Carolyn Schnurer**
American, 1951
Brooklyn Museum Costume Collection at
The Metropolitan Museum of Art, Gift of the Brooklyn
Museum, 2009; Gift of Carolyn Schnurer, 1952
2009.300.157

APRIL | 4

20 ..

..

..

..

20 ..

..

..

..

20 ..

..

..

..

20 ..

..

..

..

20 ..

..

..

Evening shoes
American, ca. 1927
Brooklyn Museum Costume Collection at
The Metropolitan Museum of Art, Gift of the Brooklyn
Museum, 2009; Gift of Herman Delman, 1955
2009.300.1206a, b

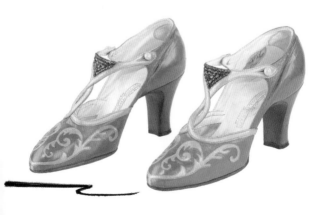

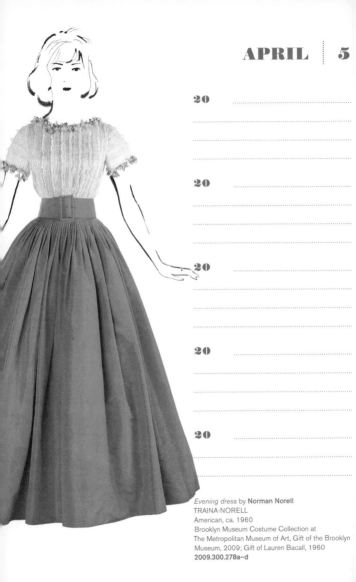

20

20

20

20

20

Evening dress by **Norman Norell**
TRAINA-NORELL
American, ca. 1960
Brooklyn Museum Costume Collection at
The Metropolitan Museum of Art, Gift of the Brooklyn
Museum, 2009; Gift of Lauren Bacall, 1960
2009.300.278a–d

APRIL | 6

20

...
...
...

20

...
...
...

20

...
...
...

20

...
...
...

20

...
...
...

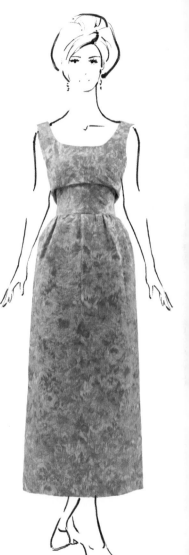

Evening dress by **Cristobal Balenciaga**
HOUSE OF BALENCIAGA
French, 1959–1960
Gift of Rosamond Bernier, 1989
1989.130.2a, b

20

20

20

20

20

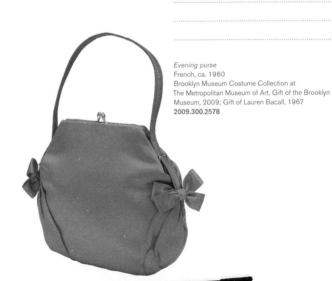

Evening purse
French, ca. 1960
Brooklyn Museum Costume Collection at
The Metropolitan Museum of Art, Gift of the Brooklyn
Museum, 2009; Gift of Lauren Bacall, 1967
2009.300.2578

20

...

...

...

20

...

...

...

20

...

...

...

20

...

...

...

20

...

...

...

Evening ensemble attributed to **Roberto Capucci**
Italian, 1958
Brooklyn Museum Costume Collection at The Metropolitan
Museum of Art, Gift of the Brooklyn Museum, 2009; Gift of
Betsy Pickering Theodoracopulos, 1966
2009.300.419a, b

20

20

20

20

20

Cocktail dress by **Madame Grès (Alix Barton)**
French, ca. 1960
Purchase, Gifts from Various Donors, 1993
1993.190

APRIL | 10

20 .. **20** ..
.. ..
.. ..
.. ..

20 .. **20** ..
.. ..
.. ..
.. ..

20 ..
..
..
..

Evening shoes by **Roger Vivier**
HOUSE OF DIOR
French, 1958
Gift of Valerian Stux-Rybar, 1979
1979.472.7a, b

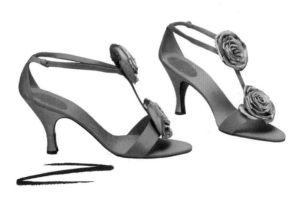

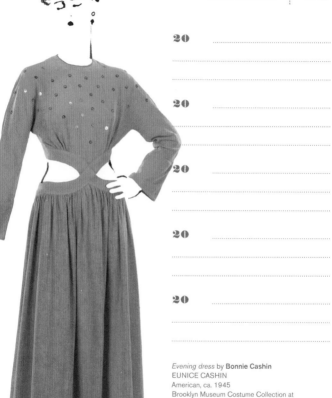

20

20

20

20

20

Evening dress by **Bonnie Cashin**
EUNICE CASHIN
American, ca. 1945
Brooklyn Museum Costume Collection at
The Metropolitan Museum of Art, Gift of the Brooklyn
Museum, 2009; Gift of Bonnie Cashin, 1962
2009.300.1296

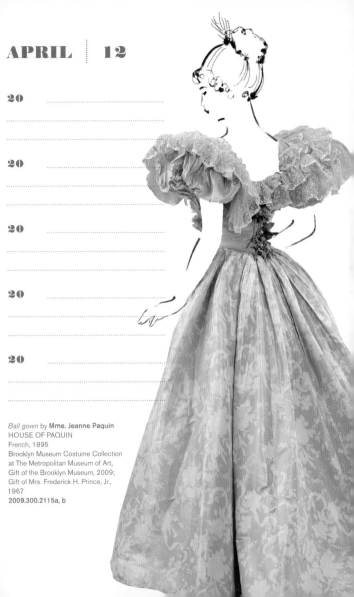

APRIL | 12

20 ...
..
..

20 ...
..
..

20 ...
..
..

20 ...
..
..

20 ...
..
..

Ball gown by **Mme. Jeanne Paquin**
HOUSE OF PAQUIN
French, 1895
Brooklyn Museum Costume Collection
at The Metropolitan Museum of Art,
Gift of the Brooklyn Museum, 2009;
Gift of Mrs. Frederick H. Prince, Jr.,
1967
2009.300.2115a, b

20 ..
..
..
..

20 ..
..
..
..

20 ..
..
..
..

20 ..
..
..
..

20 ..
..
..
..

Evening ensemble by **Madeleine Vionnet**
French, ca. 1935
Brooklyn Museum Costume Collection at
The Metropolitan Museum of Art, Gift of the Brooklyn
Museum, 2009; Gift of Mrs. James Johnson
Sweeney, 1968
2009.300.459a–g

APRIL | 14

20

.............................
.............................
.............................
.............................

20

.............................
.............................
.............................
.............................

20

.............................
.............................
.............................
.............................

20

.............................
.............................
.............................
.............................

20

.............................
.............................
.............................
.............................

Bathing suit by **Carolyn Schnurer**
American, 1951
Brooklyn Museum Costume Collection at
The Metropolitan Museum of Art, Gift of the Brooklyn
Museum, 2009; Gift of Carolyn Schnurer, 1951
2009.300.1162

20

20

20

20

20

APRIL | 16

20

20

20

20

20

Pumps by **Isabel Canovas**
French, Fall/winter 1988–1989
Gift of Richard Martin, 1993
1993.34a, b

20

.................................

.................................

.................................

20

.................................

.................................

.................................

20

.................................

.................................

.................................

20

.................................

.................................

.................................

20

.................................

.................................

.................................

20

.................................

.................................

.................................

Shoes by **Vivienne Westwood**
British, 1990
Millia Davenport and Zipporah Fleisher Fund, 2006
2006.14a, b

APRIL | 18

20

20

20

20

20

Nightgown by **Mrs. Sylvia Pedlar**
IRIS LINGERIE CO., INC.
American, 1955
Brooklyn Museum Costume Collection at
The Metropolitan Museum of Art, Gift of
the Brooklyn Museum, 2009; Gift of Sylvia
Pedlar and Mr. Philip Saffir, 1970
2009.300.3871a, b

20

...
...
...
...

20

...
...
...
...

20

...
...
...
...

20

...
...
...
...

20

...
...
...
...

Ensemble by **Gabrielle "Coco" Chanel**
HOUSE OF CHANEL
French, 1929
Isabel Shults Fund, 1984
1984.31a–c

APRIL | 20

20

...

...

...

...

20

...

...

...

...

20

...

...

...

...

20

...

...

...

...

20

...

...

Ensemble (detail) by **Gabrielle "Coco" Chanel**
HOUSE OF CHANEL
French, 1929
Isabel Shults Fund, 1984
1984.31a–c

20

20

20

Parasol by **Betaille**
French, ca. 1905
Brooklyn Museum Costume Collection at
The Metropolitan Museum of Art, Gift of the Brooklyn
Museum, 2009; Gift of Mrs. William Randolph
Hearst, Jr., 1982
2009.300.2618

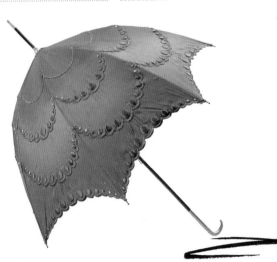

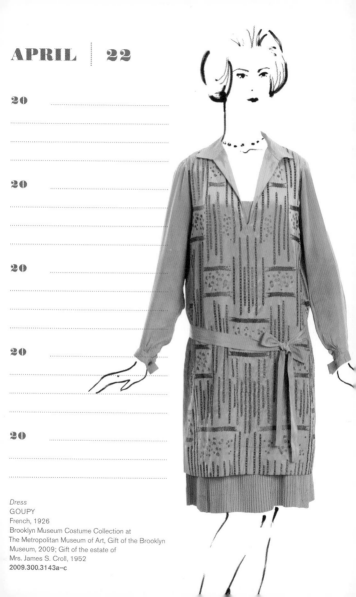

20

..

..

..

20

..

..

..

20

..

..

..

20

..

..

..

20

..

..

..

Dress
GOUPY
French, 1926
Brooklyn Museum Costume Collection at
The Metropolitan Museum of Art, Gift of the Brooklyn
Museum, 2009; Gift of the estate of
Mrs. James S. Croll, 1952
2009.300.3143a–c

20

20

20

20

20

Suit by **Bonnie Cashin**
PHILIP SILLS & CO.
American, Fall/winter 1964–1965
Gift of Helen and Philip Sills Collection of Bonnie
Cashin Clothes, 1979
1979.431.51a–c

APRIL | 24

20 ..

20 ..

20 ..

20 ..

20 ..

Bonnet
French, 1883
Gift of Mrs. Francis Howard and
Mrs. Avery Robinson, 1953
C.I.53.68.4

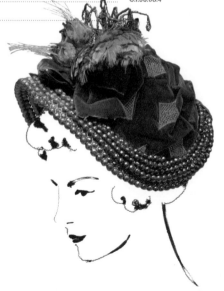

20 ...
...
...

20 ...
...
...

20 ...
...
...

20 ...
...
...

20 ...
...
...
...

Evening ensemble by **Yves Saint Laurent**
YVES SAINT LAURENT
French, Fall/winter 1976–1977
Gift of Bernice Chrysler Garbisch, 1979
1979.329.6a–d

APRIL | 26

20 ..

20 ..

20 ..

20 ..

20 ..

20 ..

20 ..

Slippers
American, ca. 1892
Brooklyn Museum Costume Collection at
The Metropolitan Museum of Art, Gift of the Brooklyn
Museum, 2009; Gift of Charlene Osgood, 1965
2009.300.1555a, b

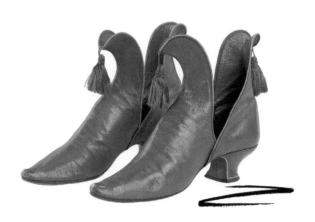

20 ...
...
...

20 ...
...
...

20 ...
...
...

20 ...
...
...

20 ...
...
...

Dress by **Ji Eon Kang**
American, Spring/summer 1997
Gift of Richard Martin, 1997
1997.250.6

APRIL | 28

20 ...

..

..

..

20 ...

..

..

..

20 ...

..

..

..

20 ...

..

..

..

20 ...

..

..

..

Pumps
DELMAN
American, 1937–1939
Brooklyn Museum Costume Collection at
The Metropolitan Museum of Art, Gift of the Brooklyn
Museum, 2009; Gift of Mrs. Lewis Iselin Jr., 1960
2009.300.3784a, b

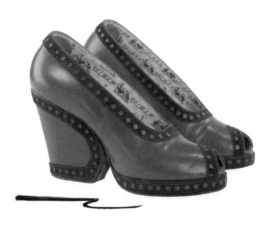

20

20

20

20

20

Coat by **Elsa Schiaparelli**
Italian, Spring 1939
Gift of Ruth Ford, 2002
2002.479.4

APRIL | 30

20

20

20

20

20

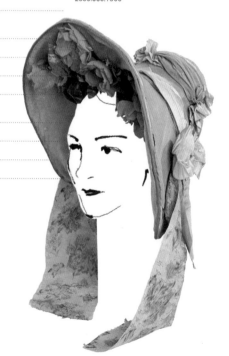

Wedding bonnet
American, 1837
Brooklyn Museum Costume Collection at
The Metropolitan Museum of Art, Gift of the Brooklyn
Museum, 2009; Gift of Mrs. Alvah E. Reed, 1966
2009.300.1560

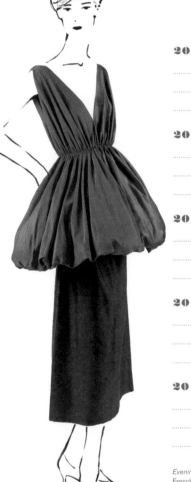

20

20

20

20

20

Evening ensemble by **Madame Grès (Alix Barton)**
French, Early 1980s
Gift of Mary M. and William W. Wilson III, 1996
1996.128.1a–d

MAY | 2

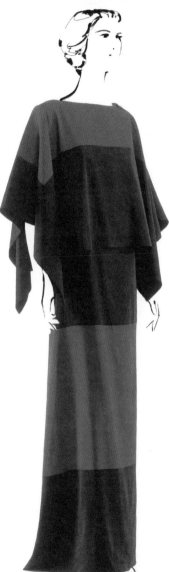

Evening dress by **Paul Poiret**
French, 1922–1923
Gift of Mrs. Muriel Draper, 1943
C.I.43.85.2a, b

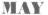

20
......................................
......................................
......................................

20
......................................
......................................
......................................

20
......................................
......................................
......................................

20
......................................
......................................
......................................

20
......................................
......................................

Evening dress by **Cristobal Balenciaga**
HOUSE OF BALENCIAGA
French, Fall/winter 1957
Brooklyn Museum Costume Collection at
The Metropolitan Museum of Art, Gift of the Brooklyn
Museum, 2009; Gift of Mrs. William Randolph
Hearst, Jr., 1963
2009.300.326

MAY | 4

20

20

20

20

20

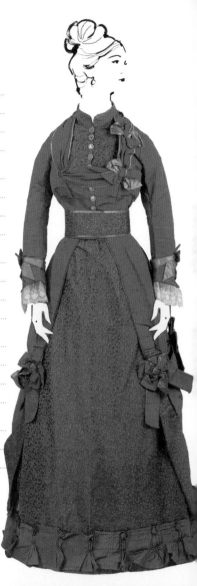

Afternoon dress by **Grace King**
American, 1870–1875
Brooklyn Museum Costume Collection at
The Metropolitan Museum of Art, Gift of
the Brooklyn Museum, 2009; Gift of
Mrs. Charles F. Junod Jr., 1964
2009.300.338a–c

20 ...

...

...

...

20 ...

...

...

...

20 ...

...

...

...

20 ...

...

...

...

20 ...

...

...

Evening slippers by **J. Ferry**
French, 1885–1895
Brooklyn Museum Costume Collection at
The Metropolitan Museum of Art, Gift of the
Brooklyn Museum, 2009; Gift of Mrs. Frederick H.
Prince, Jr., 1967
2009.300.1578a, b

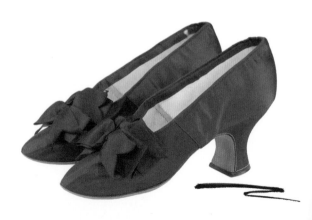

MAY | 6

20 ..

..

..

..

20 ..

..

..

..

20 ..

..

..

..

20 ..

..

..

..

20 ..

..

..

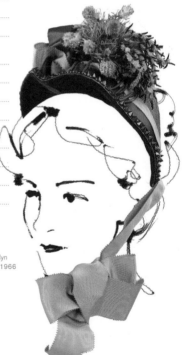

Bonnet by **H. O. Hanlon**
American, ca. 1887
Brooklyn Museum Costume Collection at
The Metropolitan Museum of Art, Gift of the Brooklyn
Museum, 2009; Gift of Amelia Beard Hollenback, 1966
2009.300.2093a–c

20

20

20

20

20

Walking ensemble
American, ca. 1835
Gift of Mrs. James Sullivan, in memory
of Mrs. Luman Reed, 1926
26.250.1a, b

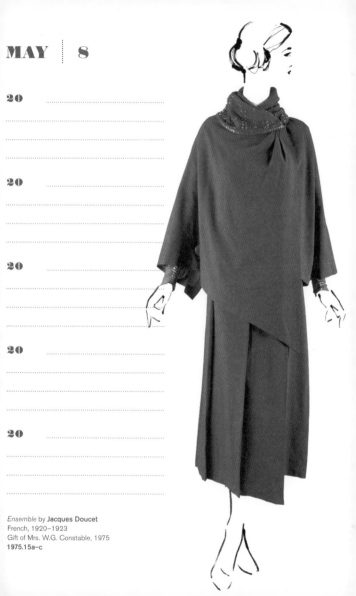

MAY | 8

Ensemble by **Jacques Doucet**
French, 1920–1923
Gift of Mrs. W.G. Constable, 1975
1975.15a–c

20

20

20

20

20

Poke bonnet
American, 1879–1884
Gift of Mrs. Charles D. Dickey, Mrs. Louis Curtis, Jr.,
and Mr. S. Sloan Colt, 1957
C.I.57.15.12

20

..................................
..................................
..................................

20

..................................
..................................
..................................

20

..................................
..................................
..................................

20

..................................
..................................
..................................

20

..................................
..................................
..................................

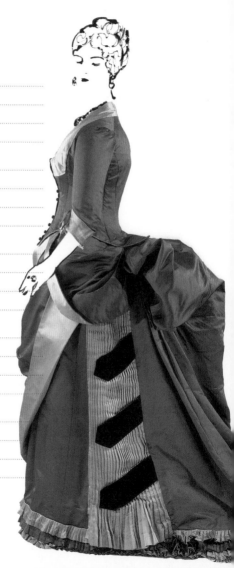

Evening dress
American or European, 1884–1886
Gift of Mrs. J. Randall Creel, 1963
C.I.63.23.3a, b

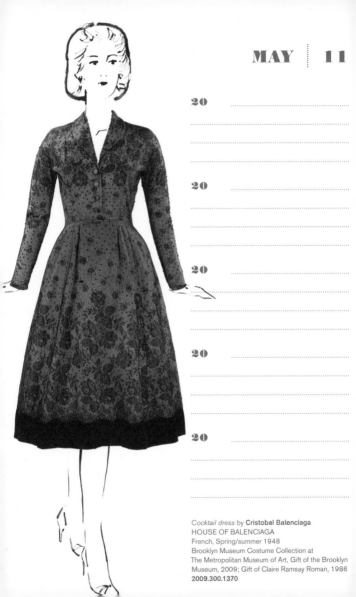

20

. .

. .

. .

20

. .

. .

. .

20

. .

. .

. .

20

. .

. .

. .

20

. .

. .

. .

Cocktail dress by **Cristobal Balenciaga**
HOUSE OF BALENCIAGA
French, Spring/summer 1948
Brooklyn Museum Costume Collection at
The Metropolitan Museum of Art, Gift of the Brooklyn
Museum, 2009; Gift of Claire Ramsay Roman, 1986
2009.300.1370

MAY | 12

20 ...

20 ...
...
...
...

20 ...
...
...
...

20 ...
...
...
...

20 ...
...
...
...

Cocktail dress (detail) by **Cristobal Balenciaga**
HOUSE OF BALENCIAGA
French, Spring/summer 1948
Brooklyn Museum Costume Collection at
The Metropolitan Museum of Art, Gift of the Brooklyn
Museum, 2009; Gift of Claire Ramsay Roman, 1986
2009.300.1370

20

20
........................
........................
........................

20

20
........................
........................
........................

20
........................
........................
........................

Hat by **Elsa Schiaparelli**
Italian, Summer 1940
Brooklyn Museum Costume Collection at
The Metropolitan Museum of Art, Gift of
the Brooklyn Museum, 2009; Gift of Millicent
Huttleston Rogers, 1951
2009.300.1446

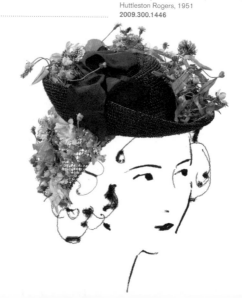

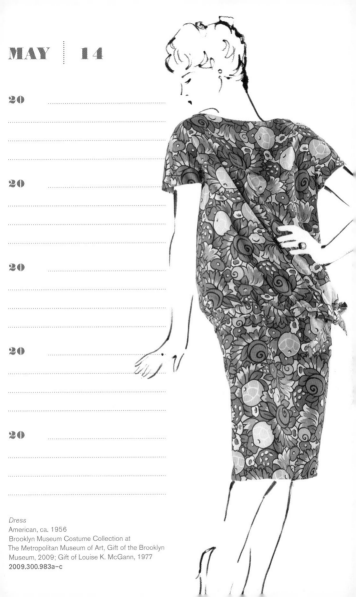

20

...

...

20

...

...

20

...

...

20

...

...

20

...

...

Dress
American, ca. 1956
Brooklyn Museum Costume Collection at
The Metropolitan Museum of Art, Gift of the Brooklyn
Museum, 2009; Gift of Louise K. McGann, 1977
2009.300.983a–c

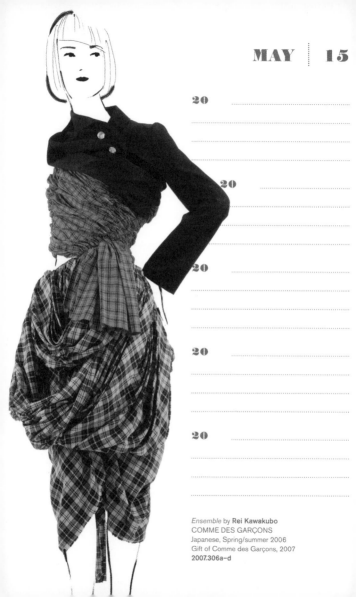

20

20

20

20

20

Ensemble by **Rei Kawakubo**
COMME DES GARÇONS
Japanese, Spring/summer 2006
Gift of Comme des Garçons, 2007
2007.306a–d

MAY | 16

20

...

...

...

20

...

...

...

20

...

...

...

20

...

...

...

20

...

...

...

"Lady Bloom" by **Noritaka Tatehana**
Japanese, 2013
Purchase, Alfred Z. Soloman-Janet A. Sloane
Endowment Fund, 2014
2014.63a, b

20

.............................
.............................
.............................
.............................

20

.............................
.............................
.............................
.............................

20

.............................
.............................
.............................
.............................

20

.............................
.............................
.............................
.............................

20

.............................
.............................
.............................
.............................

Evening ensemble by **Arnold Scaasi**
American, 1961
Brooklyn Museum Costume Collection at
The Metropolitan Museum of Art, Gift of the Brooklyn
Museum, 2009; Gift of Kay Kerr, 1965
2009.300.391a, b

MAY | 18

20

20

20

20

20

Pumps by **Mario Valentino**
V. VALENTINO
Italian, 1956
Brooklyn Museum Costume Collection at
The Metropolitan Museum of Art, Gift of the Brooklyn
Museum, 2009; Gift of Charline Osgood, 1960
2009.300.3212a, b

20

20

20

20

20

Dress by **Yves Saint Laurent**
YVES SAINT LAURENT
French, Fall/winter 1965–1966
Gift of Mrs. William Rand, 1969
C.I.69.23

MAY | 20

20

20

20

20

20

"Mondrian" by **Sally Victor**
American, ca. 1962
Brooklyn Museum Costume Collection at
The Metropolitan Museum of Art, Gift of the Brooklyn
Museum, 2009; Gift of the artist, 1964
2009.300.1320

20

20

20

20

20

Pumps by **Marc Jacobs**
American, Spring/summer 2008
Purchase, Ditty Peto Inc. Gift, 2008
2008.154a, b

MAY | 22

20

20
.....................................
.....................................
.....................................

20
.....................................
.....................................
.....................................

20
.....................................
.....................................

20
.....................................
.....................................

Hat by **Sally Victor**
American, 1936
Brooklyn Museum Costume Collection at
The Metropolitan Museum of Art, Gift of the Brooklyn
Museum, 2009; Gift of Sally Victor, Inc., 1944
2009.300.1117

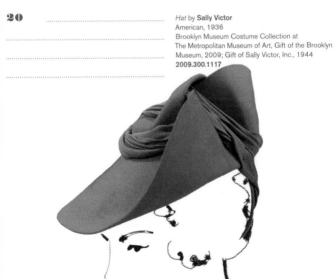

20

20

20

20

20

Dress by **Yohji Yamamoto**
Japanese, Spring/summer 2005
Purchase, Friends of The Costume Institute Gifts, 200
2006.37

MAY | 24

20 ...

...

20 ...

...

20 ...

...

20 ...

...

20 ...

...

...

Dinner dress by **Elsa Schiaparelli**
Italian, Summer 1940
Brooklyn Museum Costume Collection at
The Metropolitan Museum of Art, Gift of
the Brooklyn Museum, 2009; Gift of Arturo
and Paul Peralta-Ramos, 1955
2009.300.1210

20

20

20

Bonnet
Spanish, 1954
Brooklyn Museum Costume Collection at
The Metropolitan Museum of Art, Gift of the Brooklyn
Museum, 2009; Gift of Carolyn Schnurer, 1955
2009.300.1504

20

20

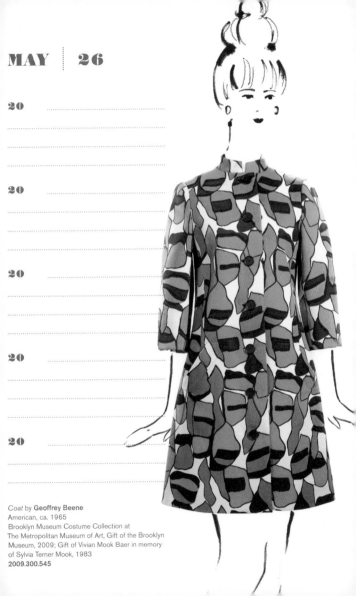

MAY | 26

20 ..

..

..

20 ..

..

..

20 ..

..

..

20 ..

..

..

20 ..

..

..

Coat by **Geoffrey Beene**
American, ca. 1965
Brooklyn Museum Costume Collection at
The Metropolitan Museum of Art, Gift of the Brooklyn
Museum, 2009; Gift of Vivian Mook Baer in memory
of Sylvia Terner Mook, 1983
2009.300.545

20 ...
...
...
...

20 ...
...
...

20 ...
...
...

20 ...
...
...
...

20 ...
...
...

Ball gown by **Arnold Scaasi**
American, Spring/summer 1988
Brooklyn Museum Costume
Collection at The Metropolitan
Museum of Art, Gift of the Brooklyn
Museum, 2009; Gift of Arnold
Scaasi, 1997
2009.300.1072

MAY | 28

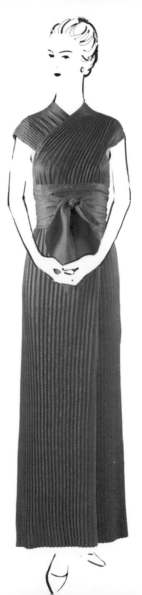

20 ..
..
..

20 ..
..
..

20 ..
..
..

20 ..
..
..

20 ..
..
..

Evening dress by **Claire McCardell**
TOWNLEY FROCKS
American, 1950
Gift of Irving Drought Harris, in memory
of Claire McCardell Harris, 1958
C.I.58.49.4a, b

20

..
..
..
..

20

..
..
..
..

20

..
..
..
..

20

..
..
..
..

20

..
..
..
..

Butard by **Paul Poiret**
French, 1912
Millia Davenport and Zipporah Fleisher Fund, 2005
2005.190a, b

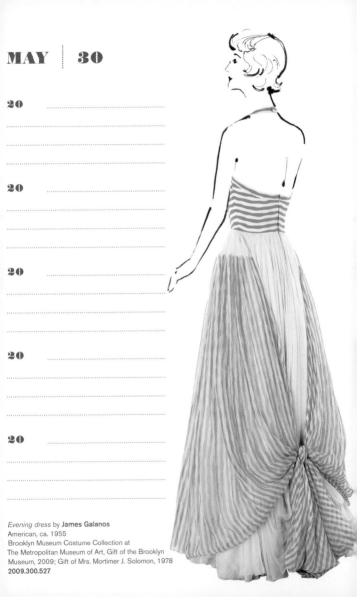

MAY | 30

20 ..

...

...

...

20 ..

...

...

...

20 ..

...

...

...

20 ..

...

...

...

20 ..

...

...

...

Evening dress by **James Galanos**
American, ca. 1955
Brooklyn Museum Costume Collection at
The Metropolitan Museum of Art, Gift of the Brooklyn
Museum, 2009; Gift of Mrs. Mortimer J. Solomon, 1978
2009.300.527

20

20

20

20

20

Bathing suit
American, 1916
Brooklyn Museum Costume Collection at
The Metropolitan Museum of Art, Gift of the Brooklyn
Museum, 2009; Brooklyn Museum Collection
2009.300.1646a, b

JUNE | 1

20 ..

..

..

20 ..

..

..

20 ..

..

..

20 ..

..

..

20 ..

..

..

Bathing suit by **Claire McCardell**
American, ca. 1957
Brooklyn Museum Costume Collection at
The Metropolitan Museum of Art, Gift of the Brooklyn
Museum, 2009; Gift of S. Capezio Inc., 1966
2009.300.3849

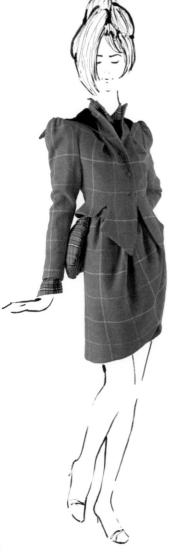

20

..........

..........

..........

..........

20

..........

..........

..........

..........

20

..........

..........

..........

..........

20

..........

..........

..........

..........

20

..........

..........

..........

..........

"On Liberty" by **Vivienne Westwood**
British, Fall/winter 1994–1995
Gift of Vivienne Westwood, 1995
1995.213a–h

JUNE | 3

20
......................................
......................................

20
......................................
......................................

20
......................................
......................................

20
......................................
......................................

20
......................................
......................................

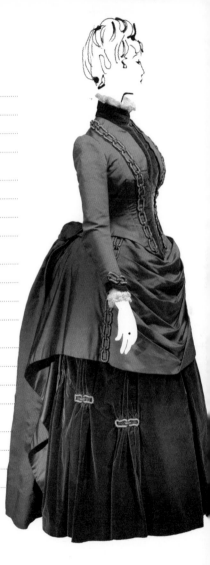

Dress
American, 1887
Gift of Mrs. James G. Flockhart, 1968
C.I.68.53.6a, b

20

................................

................................

................................

20

................................

................................

................................

20

................................

................................

................................

20

................................

................................

................................

20

................................

................................

................................

Headdress by **Paul Poiret**
French, ca. 1920
Gerson and Judith Leiber Foundation Fund, 2005
2005.206

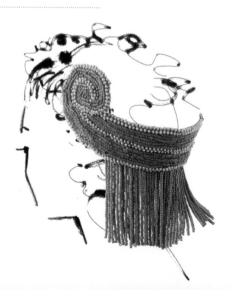

JUNE | 5

20

20

20

20

20

Shoes by J. Ferry
French, ca. 1906
Brooklyn Museum Costume Collection at
The Metropolitan Museum of Art, Gift of the
Brooklyn Museum, 2009; Gift of Mrs. Frederick H.
Prince, Jr., 1967
2009.300.1580a, b

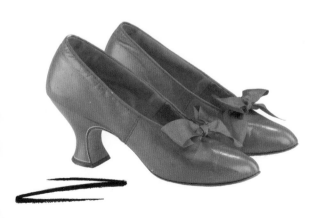

20

20

20

20

20

Evening dress by **Jean-Charles Worth**
HOUSE OF WORTH
French, ca. 1925
Brooklyn Museum Costume Collection at
The Metropolitan Museum of Art, Gift of the
Brooklyn Museum, 2009; Gift of Mrs. Frederick H.
Prince, Jr., 1967
2009.300.2116

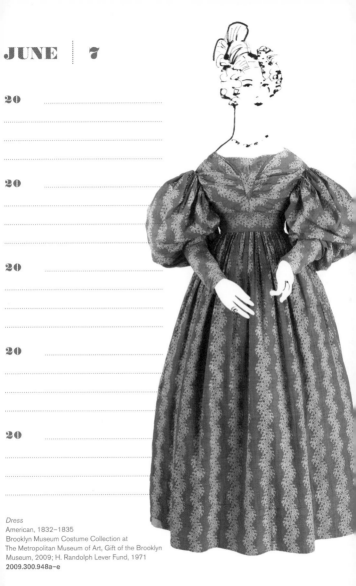

20

20

20

20

20

Dress
American, 1832–1835
Brooklyn Museum Costume Collection at
The Metropolitan Museum of Art, Gift of the Brooklyn
Museum, 2009; H. Randolph Lever Fund, 1971
2009.300.948a–e

20 ...

...

...

...

20 ...

...

...

...

20 ...

...

...

...

20 ...

...

...

...

20 ...

...

...

...

Shoes
DELMAN
American, 1937–1939
Brooklyn Museum Costume Collection at
The Metropolitan Museum of Art, Gift of the Brooklyn
Museum, 2009; Gift of Mrs. Lewis Iselin Jr., 1960
2009.300.1529a–d

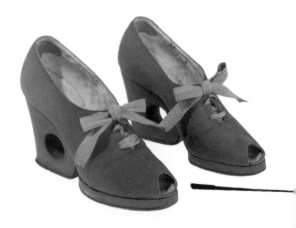

JUNE | 9

20 ...

...

...

...

20 ...

...

...

...

20 ...

...

...

...

20 ...

...

...

...

20 ...

...

...

...

Cloche
American, ca. 1925
Brooklyn Museum Costume Collection at
The Metropolitan Museum of Art, Gift of the Brooklyn
Museum, 2009; Gift of Mrs. Cuyler T. Rawlins, 1959
2009.300.1977

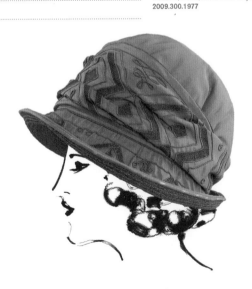

20

20

20

20

20

Evening dress by **Madame Grès (Alix Barton)**
French, Late 1960s–early 1970s
Gift of Mrs. J. Gordon Douglas, Jr., 1996
1996.448.2

JUNE | 11

20
..
..
..
..

20
..
..
..
..

20
..
..
..
..

20
..
..
..
..

20
..
..
..
..

JUNE | 12

20

20

20

20

20

Dress by **Tom Ford**
GUCCI
Italian, Spring/summer 2003
Gift of Gucci, 2003
2003.442

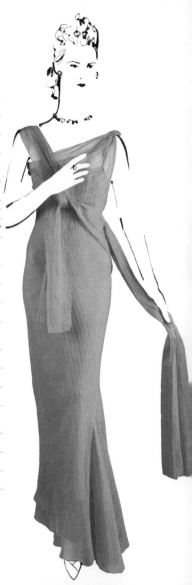

JUNE | 13

20 ..

..

..

20 ..

..

..

20 ..

..

..

20 ..

..

..

20 ..

..

..

Evening ensemble by **Elsa Schiaparelli**
Italian, 1939
Gift of Mrs. Harrison Williams, Lady Mendl,
and Mrs. Ector Munn, 1946
C.I.46.4.10a–c

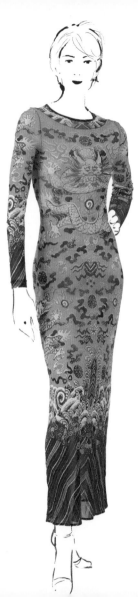

JUNE | 14

20

..
..
..
..

20

..
..
..
..

20

..
..
..
..

20

..
..
..
..

20

..
..
..
..

"Dragon Robe" by **Vivienne Tam**
American, Spring/summer 1998
Gift of Vivienne Tam, 2005
2005.72.1

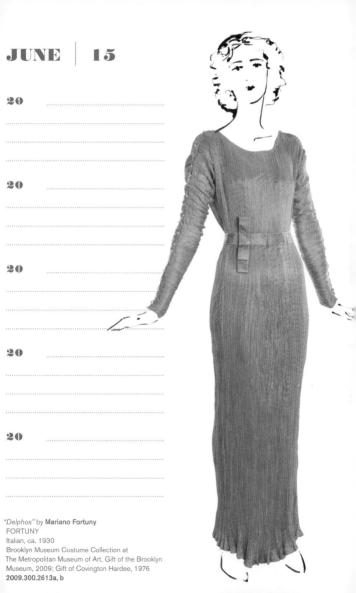

JUNE | 15

20
.................................
.................................

20
.................................
.................................

20
.................................
.................................

20
.................................
.................................

20
.................................
.................................

"Delphos" by **Mariano Fortuny**
FORTUNY
Italian, ca. 1930
Brooklyn Museum Costume Collection at
The Metropolitan Museum of Art, Gift of the Brooklyn
Museum, 2009; Gift of Covington Hardee, 1976
2009.300.2613a, b

20

. .

. .

. .

20

. .

. .

. .

20

. .

. .

. .

20

. .

. .

. .

20

. .

. .

. .

Evening ensemble by **Maisons Agnès-Drécoll**
French, 1930
Gift of Miss. Julia P. Wightman, 1990
1990.104.11a–c

20

.........................

.........................

.........................

20

.........................

.........................

.........................

20

.........................

.........................

.........................

20

.........................

.........................

.........................

20

.........................

.........................

.........................

20

.........................

.........................

Evening ensemble (detail) by **Maisons
Agnès-Drécoll**
French, 1930
Gift of Miss. Julia P. Wightman, 1990
1990.104.11a–c

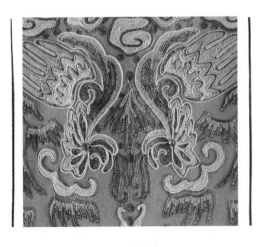

20

20

20

20

20

Dress by **Callot Soeurs**
French, ca. 1924
Gift of Julia B. Henry, 1978
1978.288.7a, b

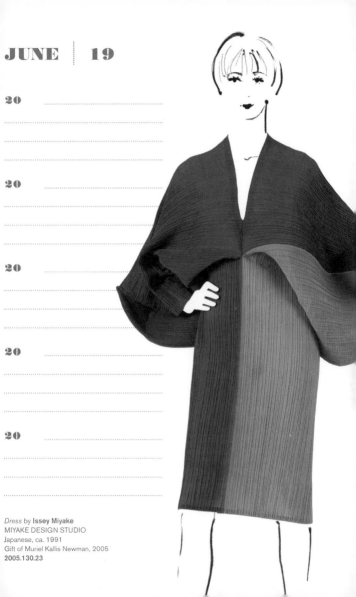

JUNE | 19

20

20

20

20

20

Dress by **Issey Miyake**
MIYAKE DESIGN STUDIO
Japanese, ca. 1991
Gift of Muriel Kallis Newman, 2005
2005.130.23

20

20

20

20

20

Evening dress by **Bonnie Cashin**
American, 1957
Brooklyn Museum Costume Collection at
The Metropolitan Museum of Art, Gift of the Brooklyn
Museum, 2009; Gift of T. Assalty, 1959
2009.300.831

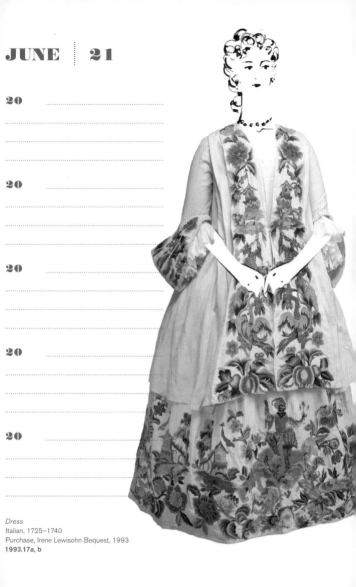

JUNE | 21

20

..

..

..

20

..

..

..

20

..

..

..

20

..

..

..

20

..

..

..

Dress
Italian, 1725–1740
Purchase, Irene Lewisohn Bequest, 1993
1993.17a, b

20 ...

20 ...

20 ...

20 ...

20 ...

Evening purse by **Paola Bordaz**
French, ca. 1935
Brooklyn Museum Costume Collection at
The Metropolitan Museum of Art, Gift of the Brooklyn
Museum, 2009; Gift of Mrs. Harry Weinstock, 1961
2009.300.2849a–c

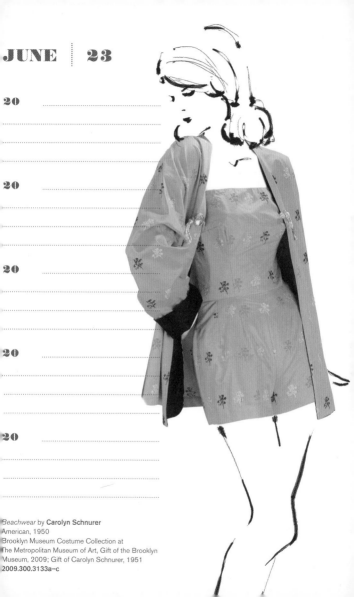

20

20

20

20

20

20 ..

..

..

20 ..

..

..

20 ..

..

..

20 ..

..

..

20 ..

..

..

Evening dress
French, 1910
Brooklyn Museum Costume Collection at
The Metropolitan Museum of Art, Gift of the Brooklyn
Museum, 2009; Gift of the estate of Mrs. Arthur F.
Schermerhorn, 1957
2009.300.246

JUNE | 25

20

..

..

..

20

..

..

..

20

..

..

..

20

..

..

..

20

..

..

..

Hat
ca. 1908
Brooklyn Museum Costume Collection at The
Metropolitan Museum of Art, Gift of the Brooklyn
Museum, 2009; Gift of Mary Elizabeth Simpson, 1942
2009.300.1770

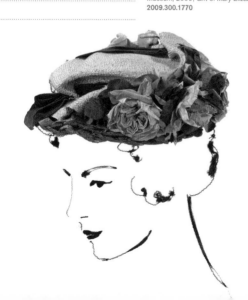

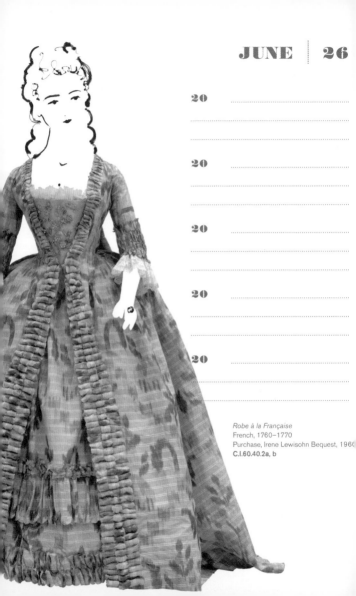

20

..........................
..........................
..........................

20

..........................
..........................
..........................

20

..........................
..........................
..........................

20

..........................
..........................
..........................

20

..........................
..........................
..........................

Robe à la Française
French, 1760–1770
Purchase, Irene Lewisohn Bequest, 1960
C.I.60.40.2a, b

JUNE | 27

20

20

20

20

20

Robe à la Française (detail)
French, 1760–1770
Purchase, Irene Lewisohn Bequest, 1960
C.I.60.40.2a, b

20

. .
. .
. .

20

. .
. .
. .

20

. .
. .
. .

20

. .
. .
. .

20

. .
. .

Dress by **Madame Marie Gerber**
CALLOT SOEURS
French, 1924
Brooklyn Museum Costume Collection at
The Metropolitan Museum of Art, Gift of
the Brooklyn Museum, 2009; Gift of the
estate of Mrs. James S. Croll, 1952
2009.300.163

JUNE | 29

20

......................................

......................................

20

......................................

......................................

20

......................................

......................................

20

......................................

......................................

20

......................................

......................................

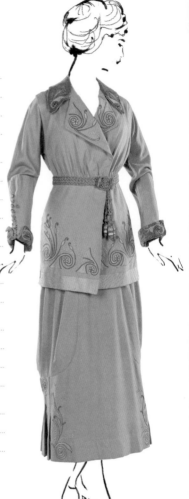

Suit
American, 1913
Brooklyn Museum Costume Collection at
The Metropolitan Museum of Art, Gift of the Brooklyn
Museum, 2009; Gift of Mrs. Joseph Warren, 1962
2009.300.16a, b

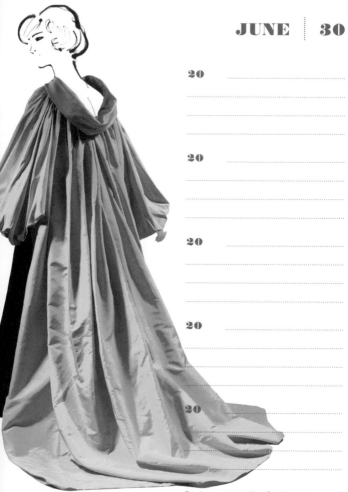

20

20

20

20

20

Evening ensemble by **Yves Saint Laurent**
YVES SAINT LAURENT
French, Fall/winter 1983–1984
Gift of Thomas L. Kempner, 2006
2006.420.51a, b

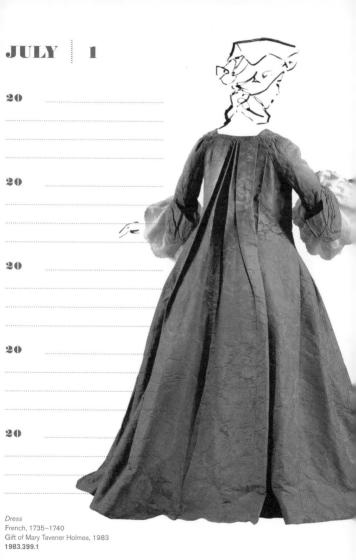

JULY | 1

20

20

20

20

20

Dress
French, 1735–1740
Gift of Mary Tavener Holmes, 1983
1983.399.1

20

..................
..................
..................

20

..................
..................
..................

20

..................
..................
..................

20

..................
..................
..................

20

..................
..................
..................

Ball gown by **Charles James**
American, 1948
Brooklyn Museum Costume Collection at
The Metropolitan Museum of Art, Gift of the Brooklyn
Museum, 2009; Gift of Arturo and Paul Peralta-
Ramos, 1954
2009.300.2787

JULY | 3

Evening shoes by **Roger Vivier**
HOUSE OF DIOR
French, 1954
Gift of Valerian Stux-Rybar, 1980
1980.597.16

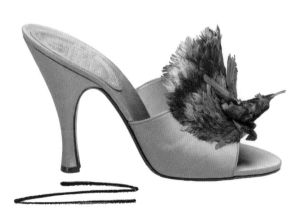

20

20

20

20

20

Robe á la Polonaise
American, 1780–1785
Gift of heirs of Emily Kearny Rodgers
Cowenhoven, 1970
1970.87a, b

JULY | 5

20 ..

20 ..
..
..
..

20 ..
..
..
..

20 ..
..
..
..

20 ..
..
..
..

20 ..
..
..

Robe à la Polonaise (detail)
American, 1780–1785
Gift of heirs of Emily Kearny Rodgers
Cowenhoven, 1970
1970.87a, b

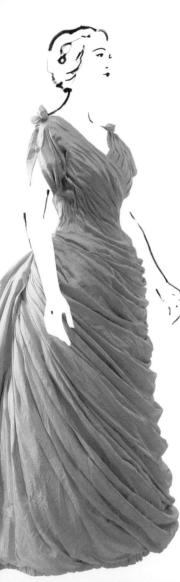

20

20

20

20

20

Evening dress
Attributed to LIBERTY & CO.
British, 1880s
Purchase, Gifts from Various Donors, 1985
1985.155

JULY | 7

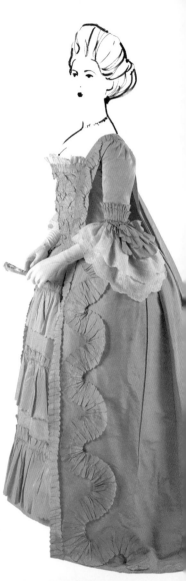

20
....................................
....................................

20
....................................
....................................

20
....................................
....................................

20
....................................
....................................

20
....................................
....................................

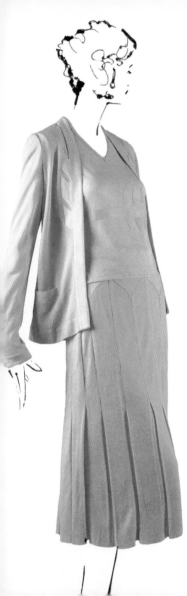

20

.....................................
.....................................
.....................................
.....................................

20

.....................................
.....................................
.....................................
.....................................

20

.....................................
.....................................
.....................................
.....................................

20

.....................................
.....................................
.....................................
.....................................

20

.....................................
.....................................
.....................................
.....................................

Dress attributed to **Jean Patou**
HOUSE OF PATOU
French, ca. 1927
Purchase, Various Funds, 1998
1998.347a–d

20

.......................................
.......................................
.......................................
.......................................

20

.......................................
.......................................
.......................................
.......................................

20

.......................................
.......................................
.......................................
.......................................

20

.......................................
.......................................
.......................................
.......................................

20

.......................................
.......................................
.......................................
.......................................
.......................................

Evening dress
American, 1924
Brooklyn Museum Costume Collection at
The Metropolitan Museum of Art, Gift of the Brooklyn
Museum, 2009; Gift of Mrs. Fred May, 1957
2009.300.1247

20 ..
..
..

20 ..
..
..

20 ..
..
..

20 ..
..
..

20 ..
..
..

Evening dress by **Marguery Bolhagen**
American, 1958
Brooklyn Museum Costume Collection at
The Metropolitan Museum of Art, Gift of the Brooklyn
Museum, 2009; Gift of Mrs. William Randolph
Hearst, Jr., 1966
2009.300.420

JULY | 11

Evening shoes by **Albanese**
Italian, 1958
Brooklyn Museum Costume Collection at
The Metropolitan Museum of Art, Gift of the Brooklyn
Museum, 2009; Gift of Charline Osgood, 1960
2009.300.3786a, b

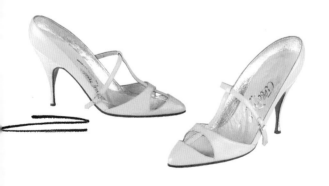

20

...................................

...................................

...................................

20

...................................

...................................

...................................

20

...................................

...................................

...................................

20

...................................

...................................

...................................

20

...................................

...................................

...................................

Cloche
GAGE BROTHERS & COMPANY
American, ca. 1922
Brooklyn Museum Costume Collection at
The Metropolitan Museum of Art, Gift of the
Brooklyn Museum, 2009; Gift of the estate
of Sarah B. Russell, 1956
2009.300.4887

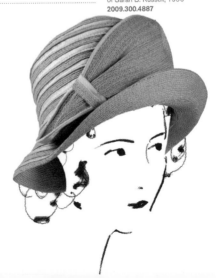

JULY | 13

20

20

20

20

20

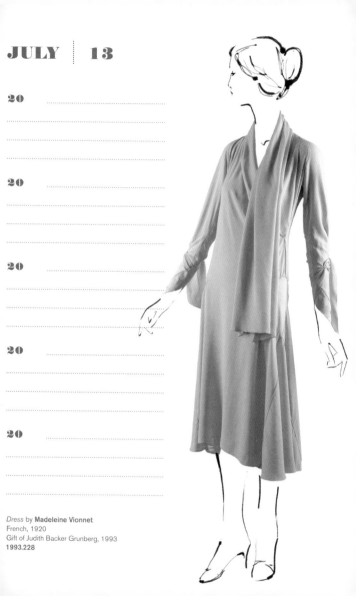

Dress by **Madeleine Vionnet**
French, 1920
Gift of Judith Backer Grunberg, 1993
1993.228

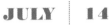

JULY | 14

20
...................................
...................................

20
...................................
...................................

20
...................................
...................................

20
...................................
...................................

20
...................................
...................................

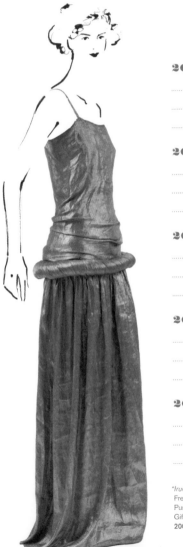

"Irudree" by **Paul Poiret**
French, 1922
Purchase, Friends of The Costume Institute
Gifts, 2007
2007.146

JULY | 15

20 ..

20 ..

20 ..

20 ..

20 ..

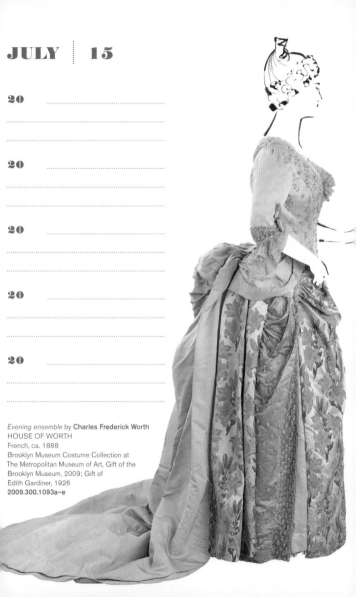

Evening ensemble by **Charles Frederick Worth**
HOUSE OF WORTH
French, ca. 1888
Brooklyn Museum Costume Collection at
The Metropolitan Museum of Art, Gift of the
Brooklyn Museum, 2009; Gift of
Edith Gardiner, 1926
2009.300.1093a–e

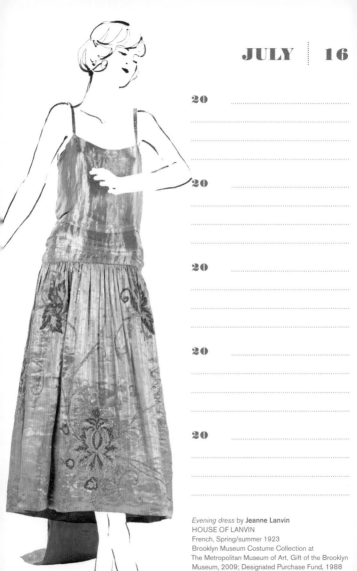

20

20

20

20

20

Evening dress by **Jeanne Lanvin**
HOUSE OF LANVIN
French, Spring/summer 1923
Brooklyn Museum Costume Collection at
The Metropolitan Museum of Art, Gift of the Brooklyn
Museum, 2009; Designated Purchase Fund, 1988
2009.300.2228a, b

JULY | 17

20 ...

20 ...
...
...
...

20 ...
...
...
...

20 ...
...
...
...

20 ...
...
...
...

Fan
French, 1860–1869
Brooklyn Museum Costume Collection at
The Metropolitan Museum of Art, Gift of the Brooklyn
Museum, 2009; Gift of Mrs. Charles C. Harris, 1968
2009.300.5647

20

20

20

20

20

Dance shoes
PALTER DELISO, INC.
American, 1951
Brooklyn Museum Costume Collection at
The Metropolitan Museum of Art, Gift of
the Brooklyn Museum, 2009; Gift of Mr.
and Mrs. Tony de Marco, 1962
2009.300.3830a, b

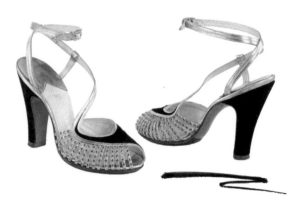

JULY | 19

Dress by **Geoffrey Beene**
American, 1983–1984
Gift of Geoffrey Beene, 2001
2001.393.49

20

20

20

20

20

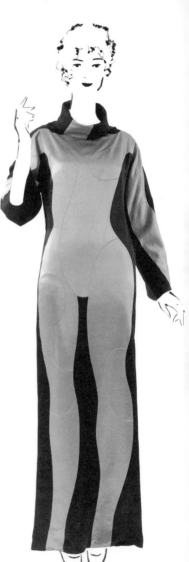

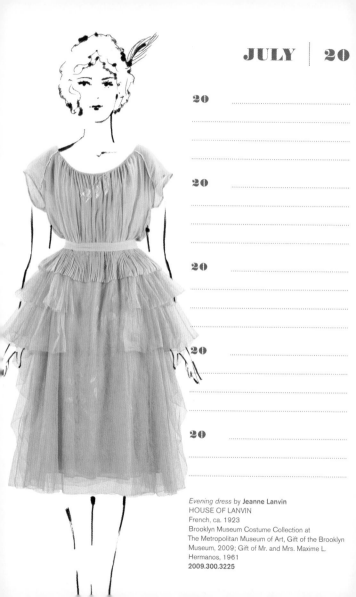

20

...
...
...
...

20

...
...
...
...

20

...
...
...
...

20

...
...
...
...

20

...
...
...

Evening dress by **Jeanne Lanvin**
HOUSE OF LANVIN
French, ca. 1923
Brooklyn Museum Costume Collection at
The Metropolitan Museum of Art, Gift of the Brooklyn
Museum, 2009; Gift of Mr. and Mrs. Maxime L.
Hermanos, 1961
2009.300.3225

JULY | 21

20

...

...

...

20

...

...

...

20

...

...

...

20

...

...

...

20

...

...

...

Pumps by **Roger Vivier**
HOUSE OF DIOR
French, 1955
Gift of Valerian Stux-Rybar, 1979
1979.472.22a, b

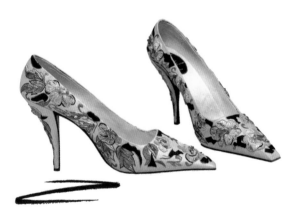

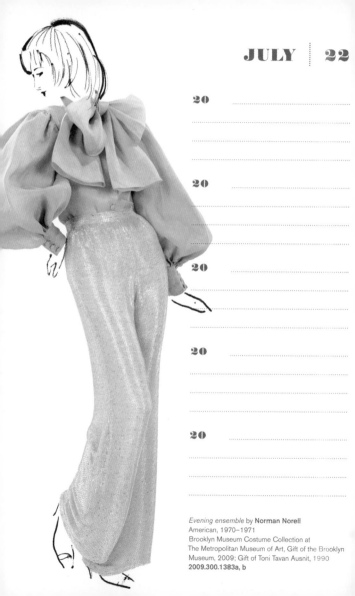

20

20

20

20

20

Evening ensemble by **Norman Norell**
American, 1970–1971
Brooklyn Museum Costume Collection at
The Metropolitan Museum of Art, Gift of the Brooklyn
Museum, 2009; Gift of Toni Tavan Ausnit, 1990
2009.300.1383a, b

JULY | 23

20 ...

...

...

...

20 ...

...

...

...

20 ...

...

...

...

20 ...

...

...

...

20 ...

...

Sandals by **Salvatore Ferragamo**
SALVATORE FERRAGAMO
Italian, 1938
Gift of Salvatore Ferragamo, 1973
1973.282.2

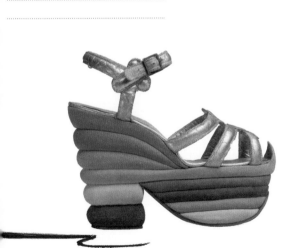

20

......................................
......................................
......................................
......................................

20

......................................
......................................
......................................
......................................

20

......................................
......................................
......................................
......................................

20

......................................
......................................
......................................
......................................

20

......................................
......................................
......................................

Evening dress by **Jean-Philippe Worth**
HOUSE OF WORTH
French, 1902
Brooklyn Museum Costume Collection at
The Metropolitan Museum of Art, Gift of the Brooklyn
Museum, 2009; Gift of Mrs. C. Oliver Iselin, 1961
2009.300.2009a, b

JULY | 25

20

20

20

20

20

Shoes by **Albanese**
Italian, 1958
Brooklyn Museum Costume Collection at
The Metropolitan Museum of Art, Gift of the Brooklyn
Museum, 2009; Gift of Charline Osgood, 1960
2009.300.3787a, b

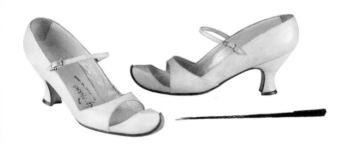

20 ..
..
..
..

20 ..
..
..
..

20 ..
..
..
..

20 ..
..
..
..

20 ..
..
..
..

Evening dress by **Jacques Doucet**
French, ca. 1902
Brooklyn Museum Costume Collection at
The Metropolitan Museum of Art, Gift of the Brooklyn
Museum, 2009; Gift of Mrs. Robert G. Olmsted, 1965
2009.300.891a–d

JULY | 27

20

20
...
...
...

20
...
...
...

20

20
...
...
...

20
...
...
...

Evening dress (detail) by **Jacques Doucet**
French, ca. 1902
Brooklyn Museum Costume Collection at
The Metropolitan Museum of Art, Gift of the Brooklyn
Museum, 2009; Gift of Mrs. Robert G. Olmsted, 1965
2009.300.891a–d

20 ...

...

...

...

20 ...

...

...

...

20 ...

...

...

20 ...

...

...

...

20 ...

...

...

...

Purse by **Emilio Pucci**
Italian, 1966–1967
Gift of Donna Schneier, 1987
1987.287.1

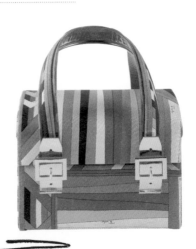

JULY | 29

20

..

..

..

20

..

..

..

20

..

..

..

20

..

..

..

20

..

..

Nightgown by **Mrs. Sylvia Pedlar**
IRIS LINGERIE CO., INC.
American, 1966
Brooklyn Museum Costume Collection at
The Metropolitan Museum of Art, Gift of the
Brooklyn Museum, 2009; Gift of Sylvia Pedlar
and Mr. Philip Saffir, 1970
2009.300.3870

20

..
..
..
..

20

..
..
..
..

20

..
..
..
..

20

..
..
..
..

20

..
..
..

Evening ensemble by **Cristobal Balenciaga**
HOUSE OF BALENCIAGA
French, 1956–1958
Brooklyn Museum Costume Collection at
The Metropolitan Museum of Art, Gift of the Brooklyn
Museum, 2009; Gift of Mrs. Gerald F. Warburg, 1980
2009.300.989a–c

20

....................
....................
....................

20

....................
....................
....................

20

....................
....................
....................

20

....................
....................
....................

20

....................
....................
....................

Promenade dress
American, ca. 1903
Brooklyn Museum Costume Collection at
The Metropolitan Museum of Art, Gift of the Brooklyn
Museum, 2009; Gift of Mrs. Ferris J. Meigs, 1961
2009.300.307a, b

20

20

20

20

20

Boots
American, ca. 1965
Purchase, Janet A. Sloane Gift, 1993
1993.318a, b

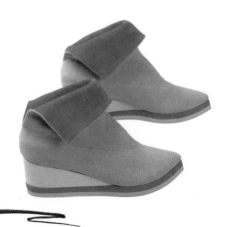

AUGUST | 2

20

.........................
.........................
.........................

20

.........................
.........................
.........................

20

.........................
.........................
.........................

20

.........................
.........................
.........................

20

.........................
.........................
.........................

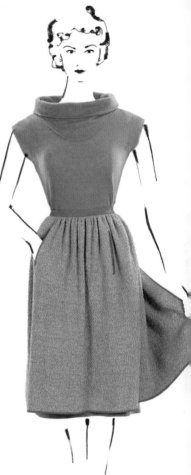

Ensemble by **Bonnie Cashin**
American, 1952
Brooklyn Museum Costume Collection at
The Metropolitan Museum of Art, Gift of the Brooklyn
Museum, 2009; Gift of Bonnie Cashin, 1986
2009.300.561a, b

20 .. 20 ..
.. ..
.. ..
.. ..

20 .. 20 ..
.. ..
.. ..

20 .. *Parasol*
.. European, 1850–1859
.. Brooklyn Museum Costume Collection at
.. The Metropolitan Museum of Art, Gift of the Brooklyn
.. Museum, 2009; Gift of Arthur Erber, 1956
 2009.300.2438

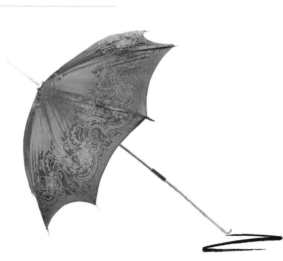

AUGUST | 4

20 ...

20 ...

20 ...

20 ...

20 ...

Hat
French, ca. 1905
Brooklyn Museum Costume Collection at
The Metropolitan Museum of Art, Gift of the Brooklyn
Museum, 2009; Gift of Helen Ray in memory of
Mr. and Mrs. William Ray and Miss M. Ray, 1951
2009.300.1452

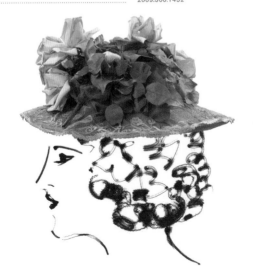

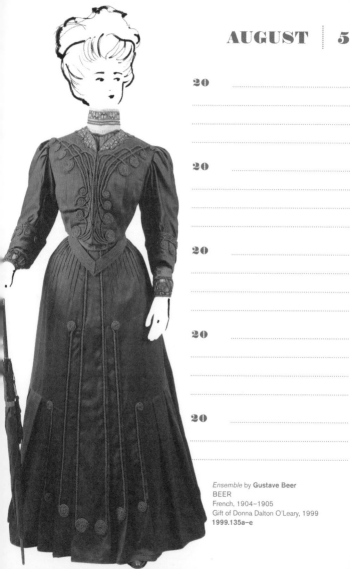

20

20

20

20

20

Ensemble by **Gustave Beer**
BEER
French, 1904–1905
Gift of Donna Dalton O'Leary, 1999
1999.135a–e

AUGUST | 6

20

20

20

20

20

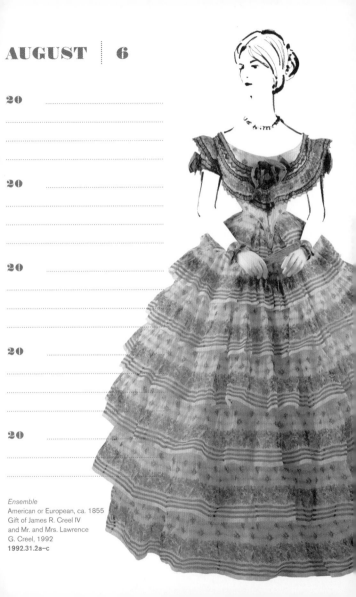

Ensemble
American or European, ca. 1855
Gift of James R. Creel IV
and Mr. and Mrs. Lawrence
G. Creel, 1992
1992.31.2a–c

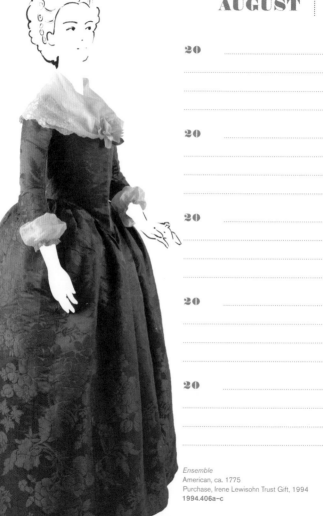

20 ...
...
...
...

20 ...
...
...
...

20 ...
...
...
...

20 ...
...
...
...

20 ...
...
...
...

Ensemble
American, ca. 1775
Purchase, Irene Lewisohn Trust Gift, 1994
1994.406a–c

AUGUST | 8

20

20

.................................

.................................

.................................

.................................

20

20

.................................

.................................

.................................

.................................

20

.................................

.................................

.................................

Fan
European, 1885–1895
Brooklyn Museum Costume Collection at
The Metropolitan Museum of Art, Gift of
the Brooklyn Museum, 2009; Gift of Countess
Edna E. de Frise, 1960
2009.300.1980

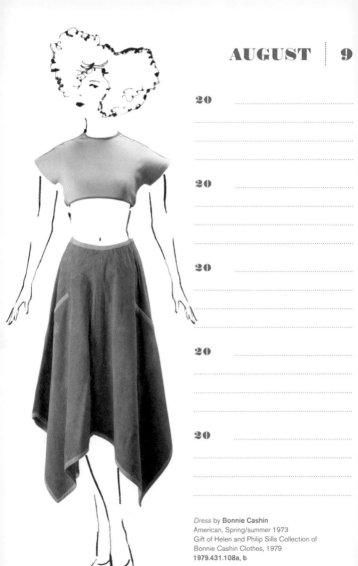

20

20

20

20

20

Dress by **Bonnie Cashin**
American, Spring/summer 1973
Gift of Helen and Philip Sills Collection of
Bonnie Cashin Clothes, 1979
1979.431.108a, b

20

20

20

20

20

Evening dress by **Emilio Pucci**
Italian, ca. 1966
Brooklyn Museum Costume Collection at
The Metropolitan Museum of Art, Gift of the Brooklyn
Museum, 2009; Gift of Mrs. Emmet Whitlock, 1985
2009.300.1024a, b

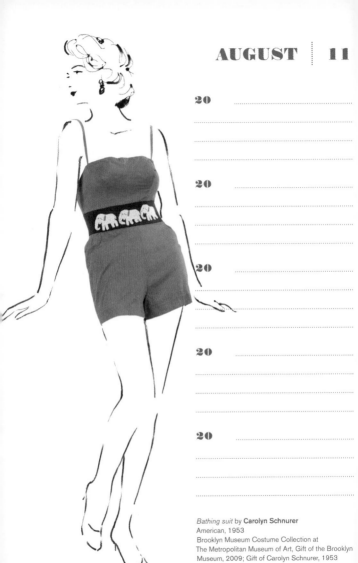

20

20

20

20

20

Bathing suit by **Carolyn Schnurer**
American, 1953
Brooklyn Museum Costume Collection at
The Metropolitan Museum of Art, Gift of the Brooklyn
Museum, 2009; Gift of Carolyn Schnurer, 1953
2009.300.1176

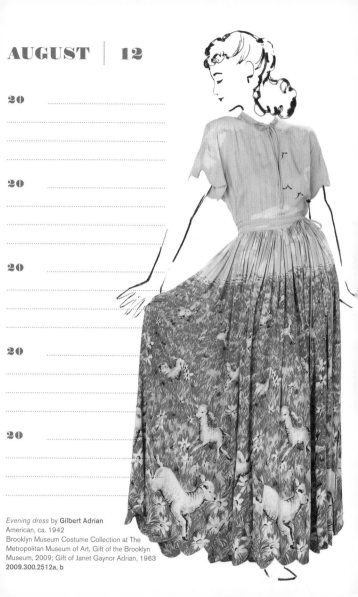

AUGUST | 12

20

...

...

...

20

...

...

...

20

...

...

...

20

...

...

...

20

...

...

...

Evening dress by **Gilbert Adrian**
American, ca. 1942
Brooklyn Museum Costume Collection at The
Metropolitan Museum of Art, Gift of the Brooklyn
Museum, 2009; Gift of Janet Gaynor Adrian, 1963
2009.300.2512a, b

20 ..

20 ..

20 ..

20 ..

20 ..

Evening shoes
DELMAN
American, 1935
Brooklyn Museum Costume Collection at
The Metropolitan Museum of Art, Gift of the Brooklyn
Museum, 2009; Gift of Herman Delman, 1955
2009.300.1492

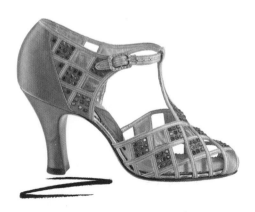

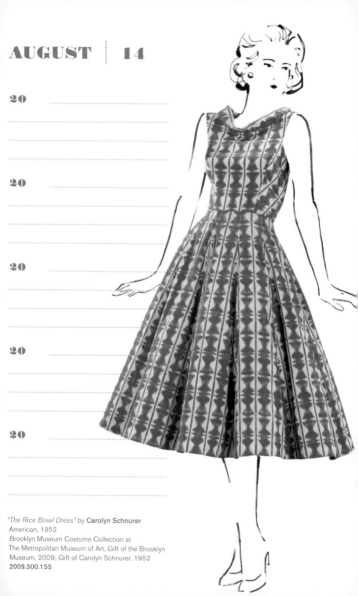

AUGUST | 14

20

.

.

.

20

.

.

.

20

.

.

.

20

.

.

.

20

.

.

.

"The Rice Bowl Dress" by **Carolyn Schnurer**
American, 1952
Brooklyn Museum Costume Collection at
The Metropolitan Museum of Art, Gift of the Brooklyn
Museum, 2009; Gift of Carolyn Schnurer, 1952
2009.300.155

20

.................................
.................................
.................................

20

.................................
.................................
.................................

20

.................................
.................................
.................................

20

.................................
.................................
.................................

20

.................................
.................................
.................................

Dress by **Diane von Furstenberg**
American, 1975–1976
Gift of Richard Martin, 1997
1997.487

AUGUST | 16

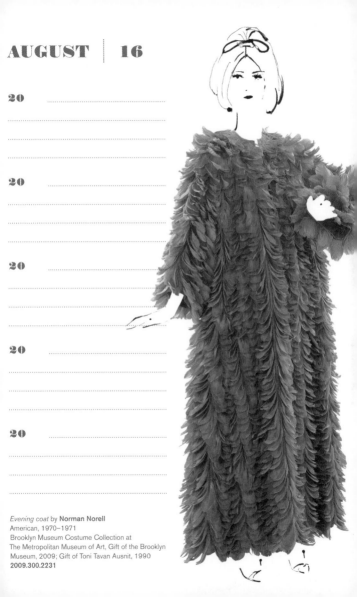

20
.......................................
.......................................
.......................................

20
.......................................
.......................................
.......................................

20
.......................................
.......................................
.......................................

20
.......................................
.......................................
.......................................

20
.......................................
.......................................
.......................................

Evening coat by **Norman Norell**
American, 1970–1971
Brooklyn Museum Costume Collection at
The Metropolitan Museum of Art, Gift of the Brooklyn
Museum, 2009; Gift of Toni Tavan Ausnit, 1990
2009.300.2231

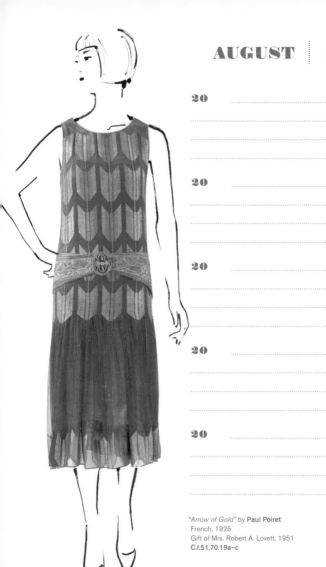

20

20

20

20

20

"Arrow of Gold" by **Paul Poiret**
French, 1925
Gift of Mrs. Robert A. Lovett, 1951
C.I.51.70.19a–c

20

20

20

20

20

Fancy dress costume by **Paul Poiret**
French, 1911
Purchase, Irene Lewisohn Trust Gift, 1983
1983.8a, b

20

20

20

20

20

Dress by **Elsa Schiaparelli,**
Italian, 1937–1938
Isabel Shults Fund, 2007
2007.18

AUGUST | 20

20

20

20

20

Mourning fan
American, 1880–1889
Brooklyn Museum Costume Collection at
The Metropolitan Museum of Art, Gift of the Brooklyn
Museum, 2009; Gift of Jane Van Vleck, 1942
2009.300.4381

AUGUST | 21

20

20

20

20

20

"Solfatare" by **Christian Dior**
HOUSE OF DIOR
French, Fall/winter 1955–1956
Gift of Mr. and Mrs. Henry Rogers Benjamin, 1965
C.I.65.14.14a, b

20

20

20

20

20

Dress
British, ca 1870
Catharine Breyer Van Bomel Foundation
Fund, 1980
1980.409.1a–c

20

...................................

...................................

...................................

20

...................................

...................................

...................................

20

...................................

...................................

...................................

20

...................................

...................................

...................................

20

...................................

...................................

...................................

Calash
American, ca. 1820
Brooklyn Museum Costume Collection at
The Metropolitan Museum of Art, Gift of
the Brooklyn Museum, 2009; Gift of Charles L.
Livingston, Jr., 1962
2009.300.2015

AUGUST | 24

Hat by **Jeanne Baron**
French, ca. 1938
Brooklyn Museum Costume Collection at
The Metropolitan Museum of Art, Gift of
the Brooklyn Museum, 2009; Gift of Mrs. William
Ford Goulding, 1969
2009.300.2146

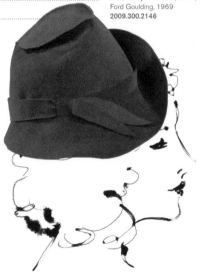

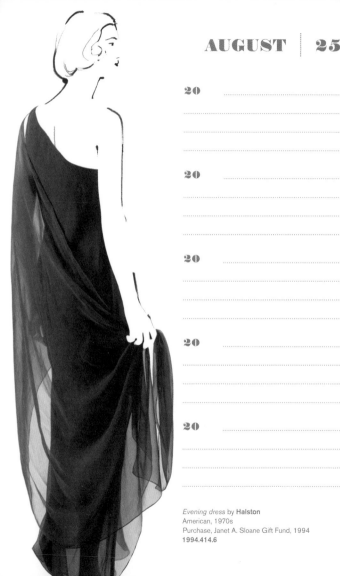

AUGUST | 25

20

20

20

20

20

Evening dress by **Halston**
American, 1970s
Purchase, Janet A. Sloane Gift Fund, 1994
1994.414.6

AUGUST | 26

20
...

...

...

...

20
...

...

...

...

20
...

...

...

...

20
...

...

...

...

20
...

...

...

...

Evening shoes by **N. Greco**
French, ca. 1926
Brooklyn Museum Costume Collection at
The Metropolitan Museum of Art, Gift of the Brooklyn
Museum, 2009; Gift of Rodman A. Heeren, 1960
2009.300.3782a, b

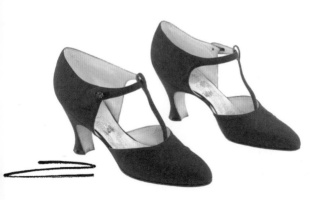

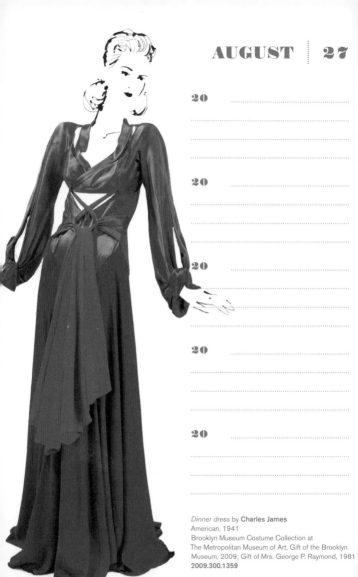

20

20

20

20

20

Dinner dress by **Charles James**
American, 1941
Brooklyn Museum Costume Collection at
The Metropolitan Museum of Art, Gift of the Brooklyn
Museum, 2009; Gift of Mrs. George P. Raymond, 1981
2009.300.1359

AUGUST | 28

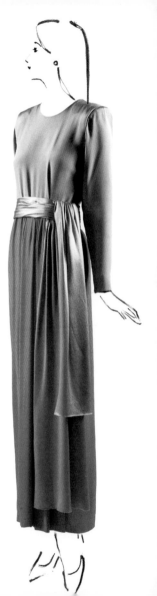

20 ...
...
...
...

20 ...
...
...
...

20 ...
...
...
...

20 ...
...
...
...

20 ...
...
...
...

Evening dress by **Yves Saint Laurent**
YVES SAINT LAURENT
French, Spring/summer 1989
Gift of Mrs. Charles Wrightsman, 1993
1993.157.6a, b

20

20

20

20

20

Evening ensemble by **Bonnie Cashin**
PHILIP SILLS & CO.
American, Fall/winter 1964–1965
Gift of Helen and Philip Sills Collection
of Bonnie Cashin Clothes, 1979
1979.431.50a, b

AUGUST | 30

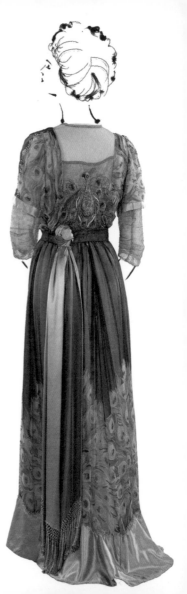

20

20

20

20

20

Evening dress
French, 1910
Brooklyn Museum Costume Collection at
The Metropolitan Museum of Art, Gift of the Brooklyn
Museum, 2009; Gift of Dr. Ruth M. Bakwin, 1961
2009.300.293

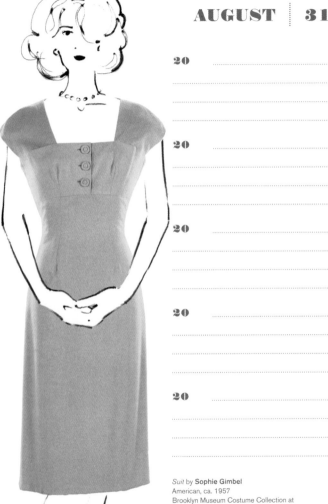

20

20

20

20

20

Suit by **Sophie Gimbel**
American, ca. 1957
Brooklyn Museum Costume Collection at
The Metropolitan Museum of Art, Gift of the Brooklyn
Museum, 2009; Gift of Sophie Gimbel, 1960
2009.300.273a, b

SEPTEMBER | 1

20

..

..

..

20

..

..

..

20

..

..

..

20

..

..

..

20

..

..

..

Evening dress
French, 1925
Brooklyn Museum Costume Collection at
The Metropolitan Museum of Art, Gift of the Brooklyn
Museum, 2009; Gift of Lewis Gompers, 1961
2009.300.1279

20

20

20

20

20

Evening shoes by **Roger Vivier**
HOUSE OF DIOR
French, 1960
Gift of Valerian Stux-Rybar, 1979
1979.472.4a, b

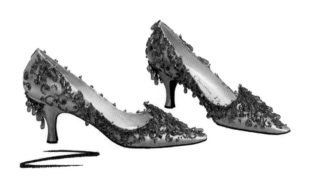

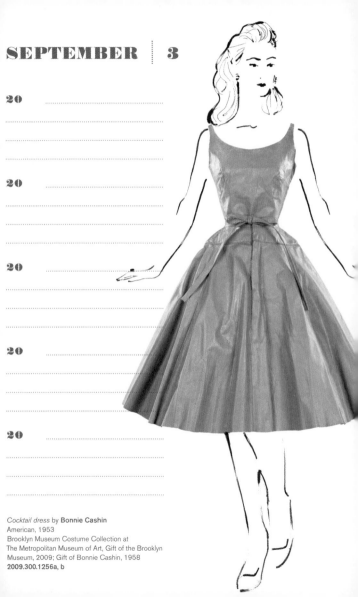

20

20

20

20

20

Cocktail dress by **Bonnie Cashin**
American, 1953
Brooklyn Museum Costume Collection at
The Metropolitan Museum of Art, Gift of the Brooklyn
Museum, 2009; Gift of Bonnie Cashin, 1958
2009.300.1256a, b

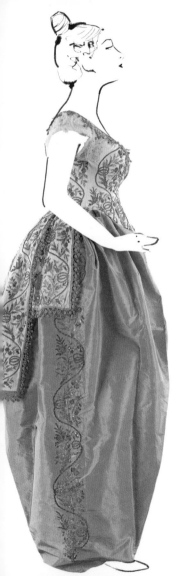

20

.............................

.............................

.............................

20

.............................

.............................

.............................

20

.............................

.............................

.............................

20

.............................

.............................

.............................

20

.............................

.............................

Fancy dress costume by **Charles Frederick Worth**
HOUSE OF WORTH
French, ca. 1870
Brooklyn Museum Costume Collection at
The Metropolitan Museum of Art, Gift of the Brooklyn
Museum, 2009; Designated Purchase Fund, 1983
2009.300.1363a, b

SEPTEMBER | 5

20

20

20

20

20

Evening shoes by **Roger Vivier**
HOUSE OF DIOR
French, 1957
Gift of Valerian Stux-Rybar, 1979
1979.472.2a, b

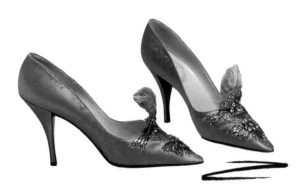

SEPTEMBER | 6

20 ..
..
..
..

20 ..
..
..
..

20 ..
..
..
..

20 ..
..
..
..

20 ..
..
..
..

Evening dress by **Giorgio di Sant'Angelo**
American, ca. 1975
Brooklyn Museum Costume Collection at
The Metropolitan Museum of Art, Gift of the Brooklyn
Museum, 2009; Gift of Trudy Elliott, 1985
2009.300.1021a, b

SEPTEMBER | 7

20

20
...................................
...................................

20
...................................
...................................

20
...................................
...................................

20
...................................
...................................

20
...................................
...................................

"Le Bal" by **Paul Poiret**
French, 1924
Purchase, Friends of The Costume Institute
Gifts, 2005
2005.192a, b

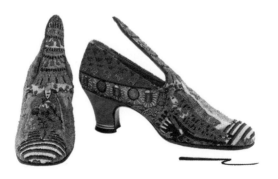

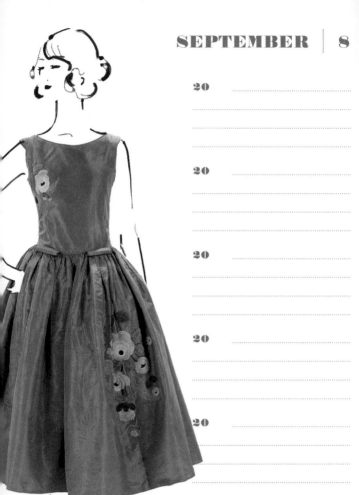

20

.....

20

.....

20

.....

20

.....

20

.....

"Jolibois" by **Jeanne Lanvin**
HOUSE OF LANVIN
French, Fall/winter 1922–1923
Brooklyn Museum Costume Collection at
The Metropolitan Museum of Art, Gift of the Brooklyn
Museum, 2009; Gift of Louise Gross, 1986
2009.300.2635

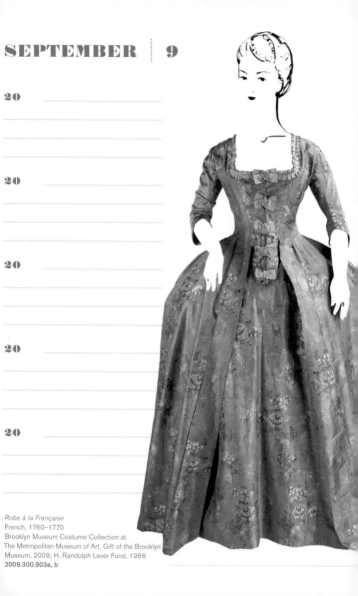

20

20

20

20

20

Robe à la Française
French, 1760–1770
Brooklyn Museum Costume Collection at
The Metropolitan Museum of Art, Gift of the Brooklyn
Museum, 2009; H. Randolph Lever Fund, 1966
2009.300.903a, b

20

20

20

20

20

Ball gown by **Charles Frederick Worth**
HOUSE OF WORTH
French, ca. 1872
Gift of Mrs. Philip K. Rhinelander, 1946
46.25.1a–d

SEPTEMBER | 11

20
......................................
......................................

20
......................................
......................................

20
......................................
......................................

20
......................................
......................................

20
......................................
......................................

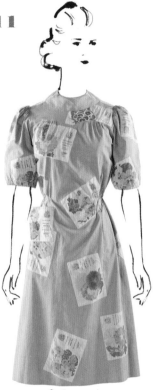

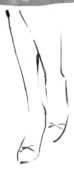

Dress by **Elsa Schiaparelli**
Italian, 1939–1941
Brooklyn Museum Costume Collection at
The Metropolitan Museum of Art, Gift of the
Brooklyn Museum, 2009; Gift of Millicent Huttleston
Rogers, 1951
2009.300.146

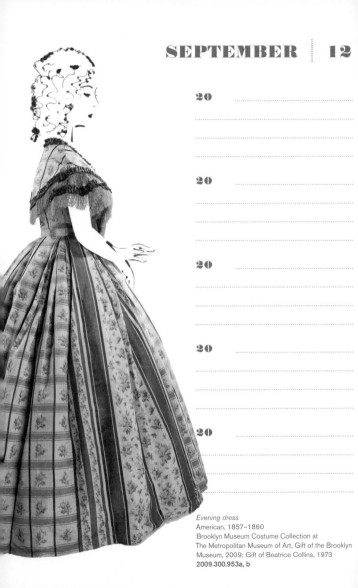

20 ...
...
...
...

20 ...
...
...
...

20 ...
...
...
...

20 ...
...
...
...

20 ...
...
...
...

Evening dress
American, 1857–1860
Brooklyn Museum Costume Collection at
The Metropolitan Museum of Art, Gift of the Brooklyn
Museum, 2009; Gift of Beatrice Collins, 1973
2009.300.953a, b

SEPTEMBER | 13

20 ..
..
..

20 ..
..
..

20 ..
..
..

20 ..
..
..

20 ..
..
..

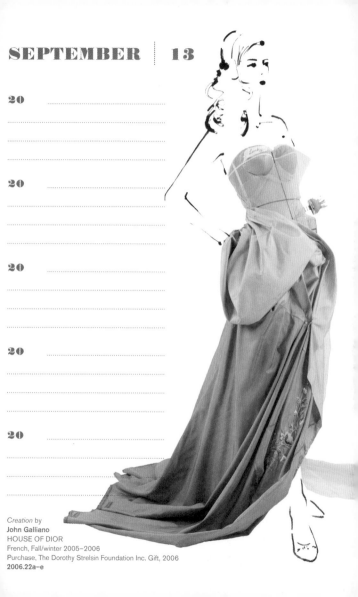

Creation by
John Galliano
HOUSE OF DIOR
French, Fall/winter 2005–2006
Purchase, The Dorothy Strelsin Foundation Inc. Gift, 2006
2006.22a–e

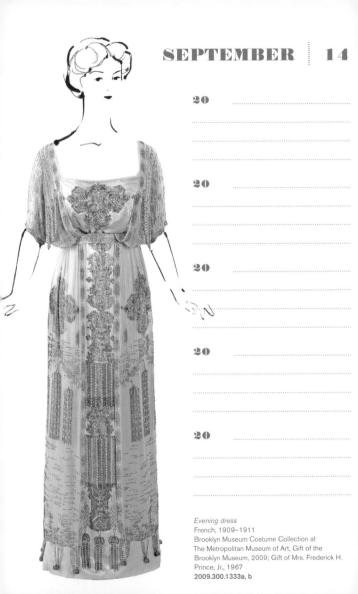

20

20

20

20

20

Evening dress
French, 1909–1911
Brooklyn Museum Costume Collection at
The Metropolitan Museum of Art, Gift of the
Brooklyn Museum, 2009; Gift of Mrs. Frederick H.
Prince, Jr., 1967
2009.300.1333a, b

SEPTEMBER | 15

20 ..
..
..

20 ..
..
..

20 ..
..
..

20 ..
..
..

20 ..
..
..

Afternoon dress by **Jacques Doucet**
French, 1900–1903
Brooklyn Museum Costume Collection at
The Metropolitan Museum of Art, Gift of the
Brooklyn Museum, 2009; Designated Purchase Fund, 1990
2009.300.579a, b

20

20

20

20

20

Evening ensemble by **Norma Kamali**
American, 1977
Gift of Eddie Kamali, 1978
1978.163.2a–c

SEPTEMBER | 17

20

.....................................

.....................................

.....................................

20

.....................................

.....................................

.....................................

20

.....................................

.....................................

20

.....................................

.....................................

.....................................

20

.....................................

.....................................

Evening boots by **Roger Vivier**
HOUSE OF DIOR
French, 1957
Gift of Valerian Stux-Rybar, 1980
1980.597.25

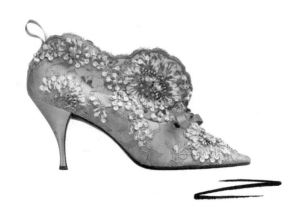

SEPTEMBER | 18

20

..
..
..
..

20

..
..
..
..

20

..
..
..
..

20

..
..
..
..

20

..
..
..
..

Evening dress
American, ca. 1918
Brooklyn Museum Costume Collection at
The Metropolitan Museum of Art, Gift of the Brooklyn
Museum, 2009; Gift of Mrs. Robert G. Olmsted and
Constable MacCracken, 1969
2009.300.2592

SEPTEMBER | 19

20 ..

..

..

..

20 ..

..

..

..

20 ..

..

..

..

20 ..

..

..

..

20 ..

..

..

..

"Matisse" by **Sally Victor**
American, ca. 1962
Brooklyn Museum Costume Collection at
The Metropolitan Museum of Art, Gift of the Brooklyn
Museum, 2009; Gift of the artist, 1964
2009.300.1321

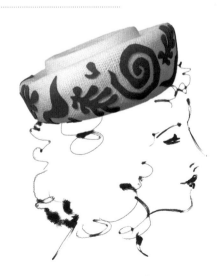

20

20

20

20

20

Evening dress by **Jeanne Hallée**
French, 1911–1915
Isabel Shults Fund, 1981
1981.328.3

SEPTEMBER | 21

20

20

20

20

20

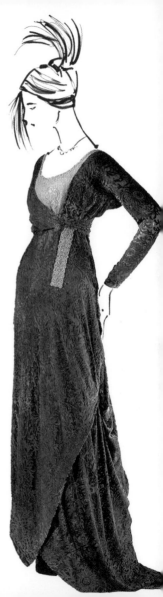

Evening dress by **Jeanne Hallée**
French, 1910–1914
Isabel Shults Fund, 1981
1981.328.9

20

20

20

20

20

Evening dress by **Thea Porter**
British, ca. 1972
Brooklyn Museum Costume Collection at
The Metropolitan Museum of Art, Gift of the Brooklyn
Museum, 2009; Gift of Mrs. Stanley Mortimer, 1976
2009.300.978

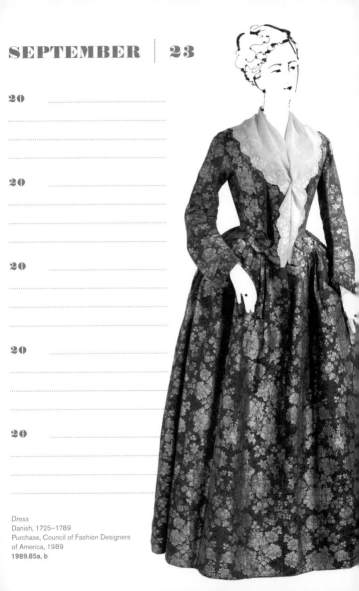

SEPTEMBER | 23

20
..
..
..

20
..
..
..

20
..
..
..

20
..
..
..

20
..
..
..

Dress
Danish, 1725–1789
Purchase, Council of Fashion Designers
of America, 1989
1989.85a, b

20

20

20

20

20

Evening shoes by **Roger Vivier**
HOUSE OF DIOR
French, 1960
Gift of Valerian Stux-Rybar, 1980
1980.597.7a, b

SEPTEMBER | 25

20

20

20

20

20

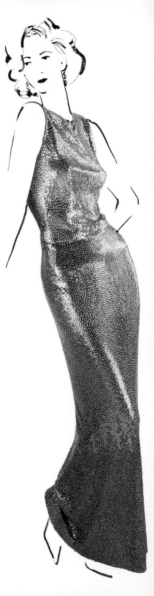

Evening dress by **Norman Norell**
TRAINA-NORELL
American, ca. 1953
Brooklyn Museum Costume Collection at
The Metropolitan Museum of Art, Gift of the Brooklyn
Museum, 2009; Gift of Mrs. Emmet Whitlock, 1983
2009.300.998

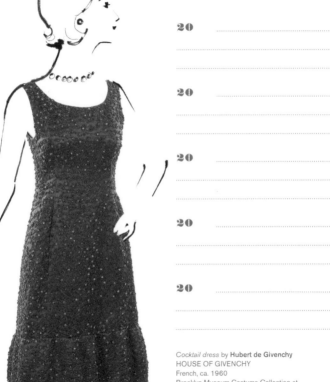

20

20

20

20

20

Cocktail dress by **Hubert de Givenchy**
HOUSE OF GIVENCHY
French, ca. 1960
Brooklyn Museum Costume Collection at
The Metropolitan Museum of Art, Gift of the Brooklyn
Museum, 2009; Gift of Mr. and Mrs. Eugene Luntey
in memory of Beverly Luntey, 2002
2009.300.606

SEPTEMBER | 27

20

20

20

20

20

Mules by **Herbert Levine Inc.**
American, 1962
Gift of Beth and Herbert Levine, 1977
1977.287.20

20

..............................

20

..............................

20

..............................

20

..............................

20

..............................

Evening purse
French, 1910–1920
Brooklyn Museum Costume Collection at
The Metropolitan Museum of Art, Gift of the Brooklyn
Museum, 2009; Gift of Mrs. Harry T. Peters, 1974
2009.300.2177

SEPTEMBER | 29

20

...
...
...

20

...
...
...

20

...
...
...

20

...
...
...

20

...
...
...

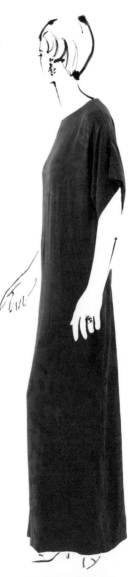

Dress by **Paul Poiret**
French, 1912
Purchase, Friends of The Costume Institute Gifts, 2005
2005.386

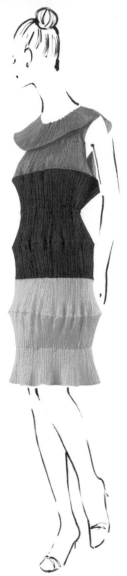

20

..
..
..
..

20

..
..
..
..

20

..
..
..
..

20

..
..
..
..

20

..
..
..
..

Dress by **Issey Miyake**
MIKAYE DESIGN STUDIO
Japanese, Spring/summer 1994
Gift of Issey Miyake, 1994
1994.603.3

OCTOBER | 1

20 ..
..
..

20 ..
..
..

20 ..
..
..

20 ..
..
..

20 ..
..
..

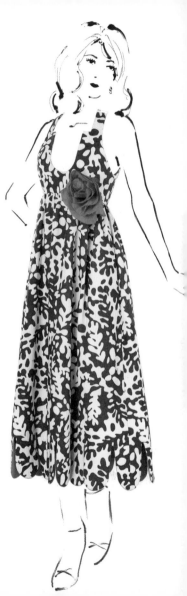

Evening dress by **Geoffrey Beene**
American, ca. 1965
Brooklyn Museum Costume Collection at
The Metropolitan Museum of Art, Gift of the Brooklyn
Museum, 2009; Gift of Mrs. George Liberman, 1975
2009.300.517

20

..
..
..
..

20

..
..
..
..

20

..
..
..
..

20

..
..
..
..

20

..
..
..
..

Afternoon ensemble
American, 1885–1888
Brooklyn Museum Costume Collection at The
Metropolitan Museum of Art, Gift of the Brooklyn
Museum, 2009; Gift of Cornelia Beall, 1963
2009.300.2033a–e

OCTOBER | 3

20 ..

..

..

..

20 ..

..

..

..

20 ..

..

..

..

20 ..

..

..

..

Hat by **Elsa Schiaparelli**
Italian, Winter 1936–1937
Brooklyn Museum Costume Collection at
The Metropolitan Museum of Art, Gift of the
Brooklyn Museum, 2009; Gift of Millicent
Huttleston Rogers, 1951
2009.300.1839

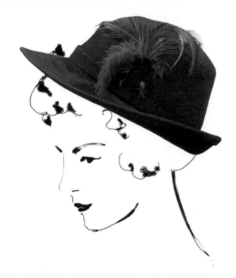

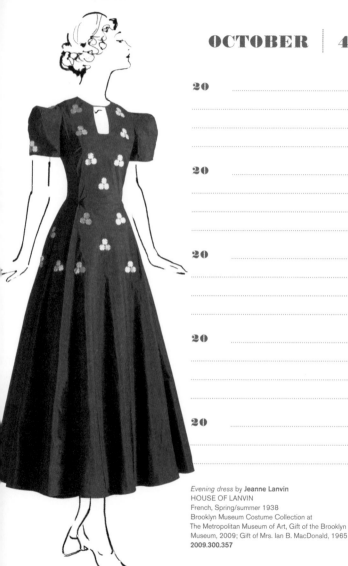

20

20

20

20

20

Evening dress by **Jeanne Lanvin**
HOUSE OF LANVIN
French, Spring/summer 1938
Brooklyn Museum Costume Collection at
The Metropolitan Museum of Art, Gift of the Brooklyn
Museum, 2009; Gift of Mrs. Ian B. MacDonald, 1965
2009.300.357

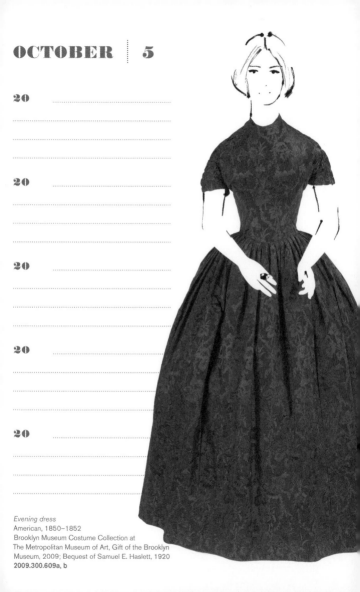

OCTOBER | 5

20

20

20

20

20

Evening dress
American, 1850–1852
Brooklyn Museum Costume Collection at
The Metropolitan Museum of Art, Gift of the Brooklyn
Museum, 2009; Bequest of Samuel E. Haslett, 1920
2009.300.609a, b

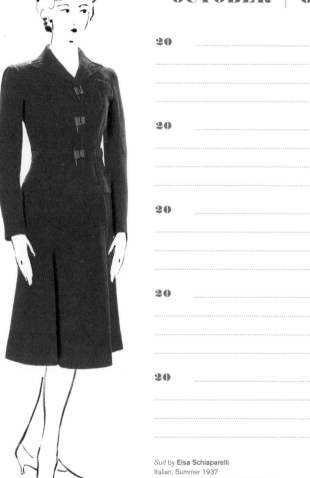

OCTOBER | 6

20

20

20

20

20

Suit by **Elsa Schiaparelli**
Italian, Summer 1937
Brooklyn Museum Costume Collection at
The Metropolitan Museum of Art, Gift of
the Brooklyn Museum, 2009; Gift of Millicent
Huttleston Rogers, 1951
2009.300.147a, b

20

.....................

20

.....................

20

.....................

20

.....................

20

.....................

Dress by **Emile Pingat**
French, ca. 1885
Brooklyn Museum Costume Collection at
The Metropolitan Museum of Art, Gift of the Brooklyn
Museum, 2009; Gift of Lillian E. Glenn Peirce and
Mabel Glenn Cooper, 1929
2009.300.628a, b

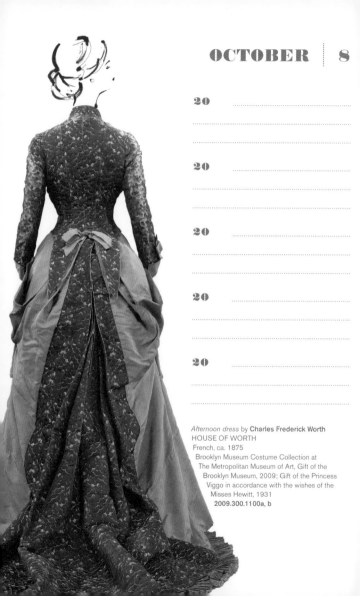

20 ...
...
...

20 ...
...
...

20 ...
...
...

20 ...
...
...

20 ...
...
...

Afternoon dress by **Charles Frederick Worth**
HOUSE OF WORTH
French, ca. 1875
Brooklyn Museum Costume Collection at
The Metropolitan Museum of Art, Gift of the
Brooklyn Museum, 2009; Gift of the Princess
Viggo in accordance with the wishes of the
Misses Hewitt, 1931
2009.300.1100a, b

OCTOBER | 9

20

20

20

20

20

Evening dress
Probably American, ca. 1932
Brooklyn Museum Costume Collection at
The Metropolitan Museum of Art, Gift of the Brooklyn
Museum, 2009; Gift of Mrs. Lucius Boomer, 1956
2009.300.2448

20 20

.. ..

.. ..

.. ..

20 20

.. ..

.. ..

..

20

..

..

..

Robe de Style (detail) by **Jeanne Lanvin**
HOUSE OF LANVIN
French, Spring/summer 1924
Gift of Mrs. Albert Spalding, 1962
C.I.62.58.1

OCTOBER | 11

20
...
...
...

20
...
...
...

20
...
...
...

20
...
...
...

20
...
...
...

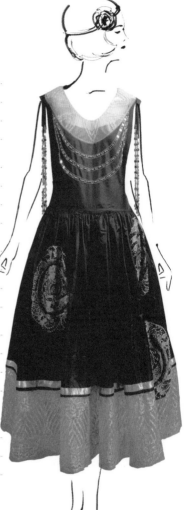

Robe de Style by **Jeanne Lanvin**
HOUSE OF LANVIN
French, Spring/summer 1924
Gift of Mrs. Albert Spalding, 1962
C.I.62.58.1

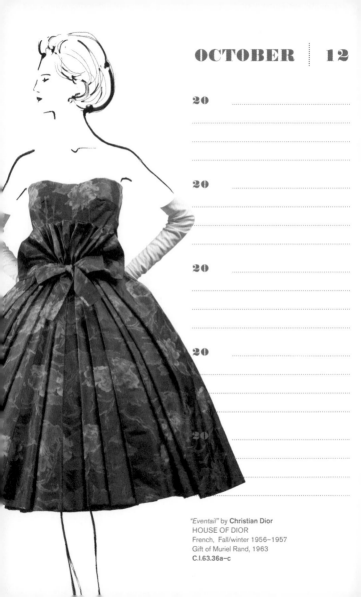

OCTOBER | 12

20

20

20

20

20

"Eventail" by **Christian Dior**
HOUSE OF DIOR
French, Fall/winter 1956–1957
Gift of Muriel Rand, 1963
C.I.63.36a–c

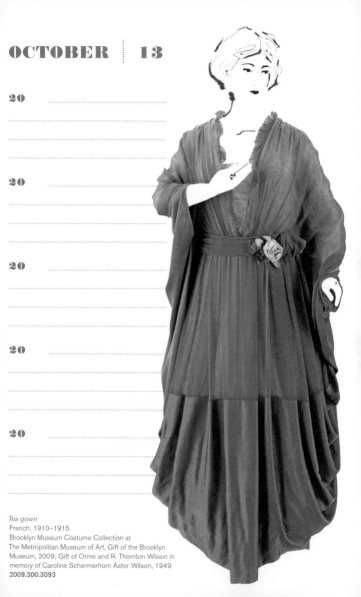

OCTOBER | 13

20

20

20

20

20

Tea gown
French, 1910–1915
Brooklyn Museum Costume Collection at
The Metropolitan Museum of Art, Gift of the Brooklyn
Museum, 2009; Gift of Orme and R. Thornton Wilson in
memory of Caroline Schermerhorn Astor Wilson, 1949
2009.300.3093

20

...

...

...

...

20

...

...

...

...

20

...

...

...

...

20

...

...

...

...

20

...

...

...

...

Evening dress by **Elsa Schiaparelli**
Italian, Fall 1938
Brooklyn Museum Costume Collection at
The Metropolitan Museum of Art, Gift of the
Brooklyn Museum, 2009; Gift of Millicent
Huttleston Rogers, 1951
2009.300.1166a, b

OCTOBER | 15

20

20

20

20

20

Promenade bonnet
American, 1882
Gift of Mrs. Robert S. Kilborne, 1958
C.I.58.67.29

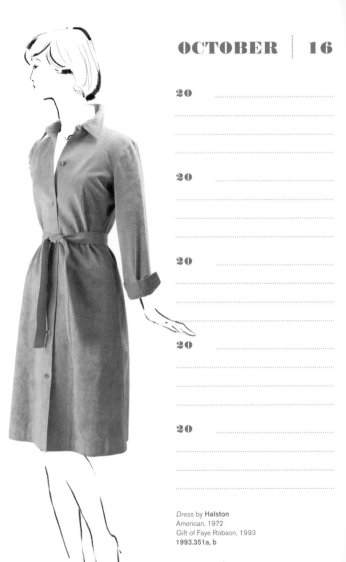

OCTOBER | 16

20

20

20

20

20

Dress by **Halston**
American, 1972
Gift of Faye Robson, 1993
1993.351a, b

OCTOBER | 17

20

20

20

20

20

Evening ensemble by **Hubert de Givenchy**
HOUSE OF GIVENCHY
French, 1956
Brooklyn Museum Costume Collection at The Metropolitan
Museum of Art, Gift of the Brooklyn Museum, 2009; Gift of
Mrs. William Randolph Hearst, Jr., 1962
2009.300.857a–c

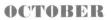

OCTOBER | 18

20

20

20

20

20

Round gown
Italian, ca. 1795
Purchase, Irene Lewisohn Bequest, 1979
1979.20a–e, g

OCTOBER | 19

20 ...

20 ...

20 ...

20 ...

20 ...

Dinner toque
American, 1909
Brooklyn Museum Costume Collection at
The Metropolitan Museum of Art, Gift of the Brooklyn
Museum, 2009; Gift of Mrs. M. Firth, 1961
2009.300.1532

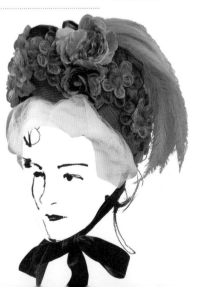

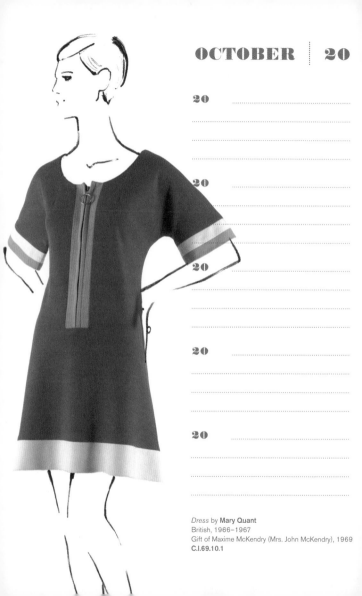

20

20

20

20

20

Dress by **Mary Quant**
British, 1966–1967
Gift of Maxime McKendry (Mrs. John McKendry), 1969
C.I.69.10.1

20

....................................

....................................

....................................

20

....................................

....................................

....................................

20

....................................

....................................

....................................

20

....................................

....................................

....................................

20

....................................

....................................

....................................

Parasol
LYON
French, 1890–1899
Brooklyn Museum Costume Collection at
The Metropolitan Museum of Art, Gift of the Brooklyn
Museum, 2009; Gift of Mrs. C. D. Waters, 1945
2009.300.2359

20

20

20

20

20

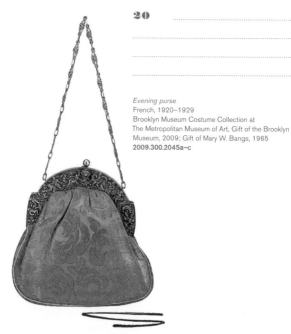

Evening purse
French, 1920–1929
Brooklyn Museum Costume Collection at
The Metropolitan Museum of Art, Gift of the Brooklyn
Museum, 2009; Gift of Mary W. Bangs, 1965
2009.300.2045a–c

OCTOBER | 23

20
.................................

20
.................................

20
.................................

20
.................................

20
.................................

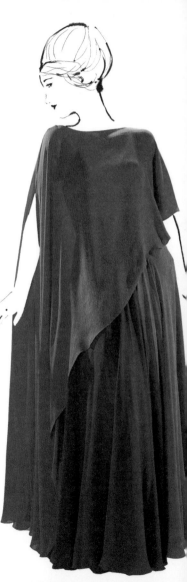

Evening ensemble by **Madame Grès (Alix Barton)**
French, 1967
Brooklyn Museum Costume Collection at
The Metropolitan Museum of Art, Gift of the
Brooklyn Museum, 2009; Gift of Mrs. William
Randolph Hearst, Jr., 1988
2009.300.1042a, b

20

20

20

20

20

Evening slippers
French, 1885–1990
Brooklyn Museum Costume Collection at
The Metropolitan Museum of Art, Gift of the
Brooklyn Museum, 2009; Gift of Mrs. Frederick H.
Prince, Jr., 1967
2009.300.1579a, b

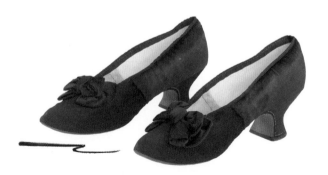

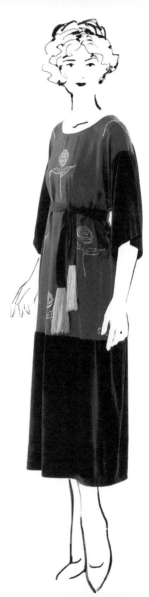

OCTOBER | 25

20

.......................................

.......................................

.......................................

20

.......................................

.......................................

.......................................

20

.......................................

.......................................

.......................................

20

.......................................

.......................................

.......................................

20

.......................................

.......................................

.......................................

"La Rose d'Iribe" by **Paul Poiret**
French, 1913
Textile designed by **Raoul Dufy**
Millia Davenport and Zipporah Fleisher Fund, 2005
2005.198a, b

20
.....................................
.....................................
.....................................

20
.....................................
.....................................
.....................................

20
.....................................
.....................................
.....................................

20
.....................................
.....................................
.....................................

20
.....................................
.....................................
.....................................

Boots by **Jerry Edouard**
American, ca. 1975
Brooklyn Museum Costume Collection at
The Metropolitan Museum of Art, Gift of
the Brooklyn Museum, 2009; Gift of Mrs.
Mortimer J. Solomon, 1978
2009.300.1610a, b

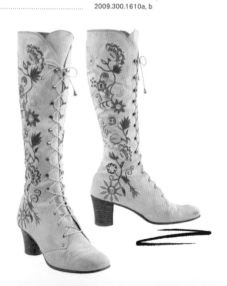

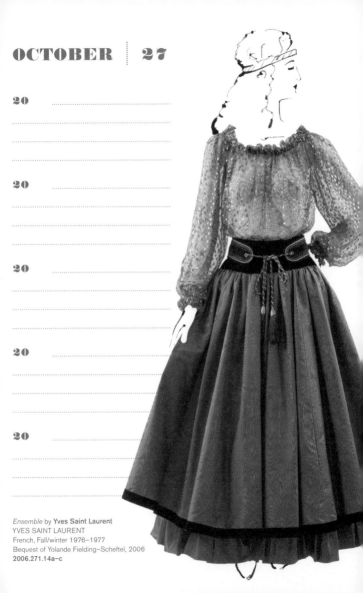

OCTOBER | 27

20

20

20

20

20

Ensemble by **Yves Saint Laurent**
YVES SAINT LAURENT
French, Fall/winter 1976–1977
Bequest of Yolande Fielding–Scheftel, 2006
2006.271.14a–c

20

20

20

20

20

Evening dress
French, 1902
Gift of Miss Irene Lewisohn, 1937
C.I.37.44.2a, b

OCTOBER | 29

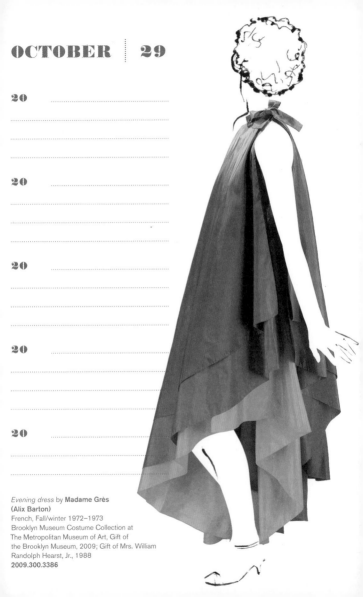

20 ..

..

..

20 ..

..

..

20 ..

..

..

20 ..

..

..

20 ..

..

..

Evening dress by **Madame Grès**
(Alix Barton)
French, Fall/winter 1972–1973
Brooklyn Museum Costume Collection at
The Metropolitan Museum of Art, Gift of
the Brooklyn Museum, 2009; Gift of Mrs. William
Randolph Hearst, Jr., 1988
2009.300.3386

20

20

20

20

20

Slippers
American, 1865–1885
Brooklyn Museum Costume Collection at
The Metropolitan Museum of Art, Gift of the Brooklyn
Museum, 2009; Gift of Beulah Stevenson, 1958
2009.300.1517a, b

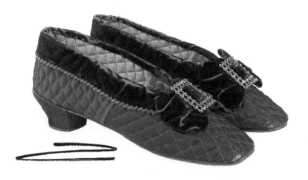

OCTOBER | 31

20

...

...

...

20

...

...

...

20

...

...

...

20

...

...

...

20

...

...

...

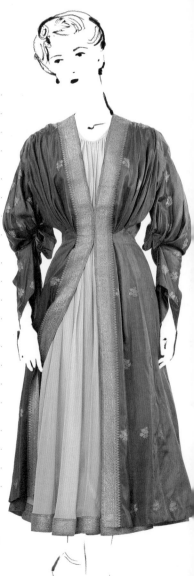

Evening dress by **Mainbocher**
American, ca. 1948
Brooklyn Museum Costume Collection at
The Metropolitan Museum of Art, Gift of the Brooklyn
Museum, 2009; Gift of Mrs. Paul P. Ramos, 1962
2009.300.315a, b

20

20

20

20

20

Snood
American, ca. 1943
Brooklyn Museum Costume Collection at
The Metropolitan Museum of Art, Gift of the Brooklyn
Museum, 2009; Gift of Mrs. Myles Friedman, 1960
2009.300.1986

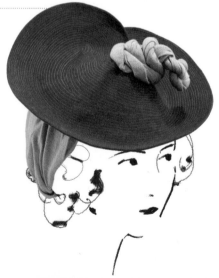

NOVEMBER | 2

20

20

20

20

20

Bonnet
AITKEN SON & COMPANY
American, ca. 1885
Brooklyn Museum Costume Collection at
The Metropolitan Museum of Art, Gift of the Brooklyn
Museum, 2009; Gift of Mrs. John King, 1959
2009.300.1972

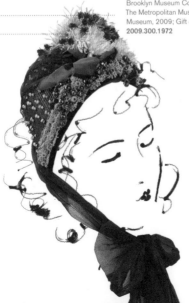

20 ...
...
...
...

20 ...
...
...
...

20 ...
...
...
...

20 ...
...
...
...

20 ...
...
...
...

Dress by **Stephen Burrows**
American, Early 1970s
Gift of Muriel Kallis Newman, 1987
1987.136.20

NOVEMBER | 4

20 ...

20 ...

20 ...

20 ...

20 ...

Hat by **Claude Saint-Cyr**
French, ca. 1950
Brooklyn Museum Costume Collection at
The Metropolitan Museum of Art, Gift of the Brooklyn
Museum, 2009; Gift of Evelyn Metzger, 1992
2009.300.2648

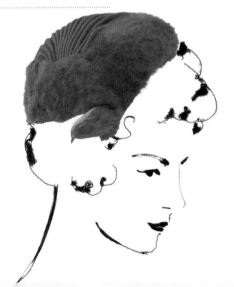

20 ...

20 ...

20 ...

20 ...

20 ...

Boots
American, 1865–1875
Brooklyn Museum Costume Collection at
The Metropolitan Museum of Art, Gift of the Brooklyn
Museum, 2009; H. Randolph Lever Fund, 1967
2009.300.3319a, b

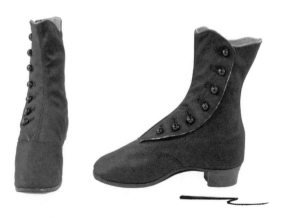

NOVEMBER | 6

20 ..

20 ..

20 ..

20 ..

20 ..

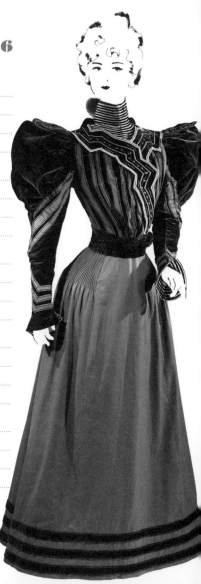

Suit
American, 1894–1896
Gift of The New York Historical Society, 1979
1979.346.25a–c

20

20

20

20

20

20
........................
........................
........................
........................

Hat by **Sally Victor**
American, 1937
Brooklyn Museum Costume Collection at
The Metropolitan Museum of Art, Gift of the Brooklyn
Museum, 2009; Gift of Sally Victor, Inc., 1944
2009.300.1788

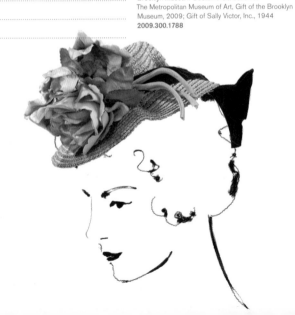

NOVEMBER | 8

20

20

20

20

20

Evening purse
French, 1920–1929
Brooklyn Museum Costume Collection at
The Metropolitan Museum of Art, Gift of the Brooklyn
Museum, 2009; Gift of Lee Harwood in memory of
Anne Harwood, 1977
2009.300.2185a, b

Evening dress
American, 1893
Brooklyn Museum Costume Collection at
The Metropolitan Museum of Art, Gift of the Brooklyn
Museum, 2009; Gift of Edwin A. Neugass, 1959
2009.300.838a–c

NOVEMBER | 10

20

20

20

20

20

Oxfords
THE CHELSEA COBBLER
British, ca. 1970
Brooklyn Museum Costume Collection at
The Metropolitan Museum of Art, Gift of the Brooklyn
Museum, 2009; Gift of Jane Holzer, 1986
2009.300.3896a–d

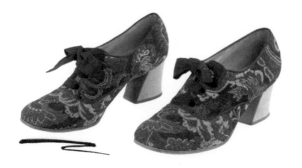

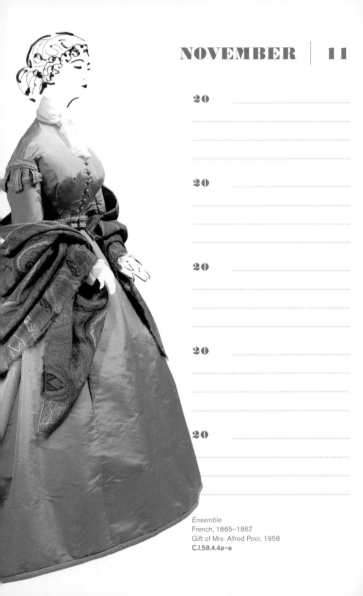

20

..
..
..
..

20

..
..
..
..

20

..
..
..
..

20

..
..
..
..

20

..
..
..
..

Ensemble
French, 1865–1867
Gift of Mrs. Alfred Poor, 1958
C.I.58.4.4a–e

NOVEMBER | 12

20 ..

..

..

20 ..

..

..

20 ..

..

..

20 ..

..

..

20 ..

..

..

Wedding ensemble by **Herman Rossberg**
American, 1887
Gift of Mrs. James G. Flockhart, 1968
C.I.68.53.5a–h

20

20

20

20

20

20

Evening slippers by **Roger Vivier**
HOUSE OF DIOR
French, 1960
Gift of Valerian Stux-Rybar, 1980
1980.597.6a, b

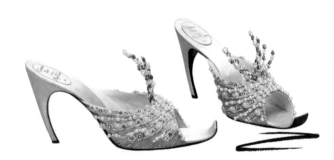

20

.................................
.................................
.................................

20

.................................
.................................
.................................

20

.................................
.................................
.................................

20

.................................
.................................
.................................

20

.................................
.................................
.................................

Evening dress by **Madame Grès**
(Alix Barton)
French, 1951
Gift of Mrs. Robert E. Pabst, 1994
1994.580.4a, b

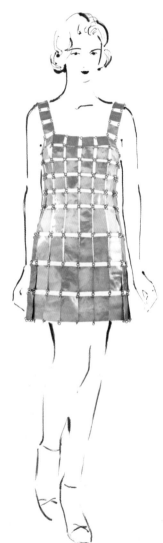

NOVEMBER | 15

20 ..
..
..

20 ..
..
..

20 ..
..
..

20 ..
..
..

20 ..
..
..
..

Dress by **Paco Rabanne**
French, 1967
Purchase, Gould Family Foundation Gift, in memory
of Jo Copeland, 2008
2008.305

NOVEMBER | 16

20

20

20

20

20

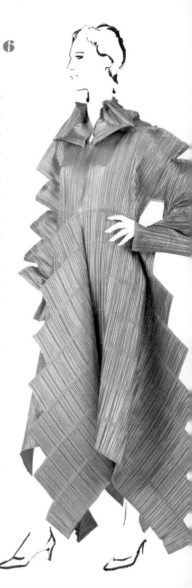

"Staircase Pleats" by **Issey Miyake**
MIYAKE DESIGN STUDIO
Japanese, Fall/winter 1994–1995
Gift of Muriel Kallis Newman, 2005
2005.130.11

20

20

20

20

20

Evening dress by **Geoffrey Beene**
American, 1991
Gift of Anne H. Bass, 1993
1993.345.12

NOVEMBER | 18

20

20

20

20

20

Evening shoes
BOB, INC., N.Y.
American, ca. 1925
Gift of Mrs. R. C. Jacobsen, 1954
C.I.54.14.2a, b

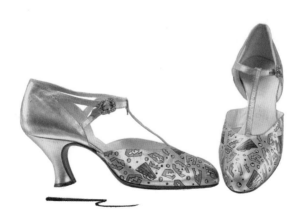

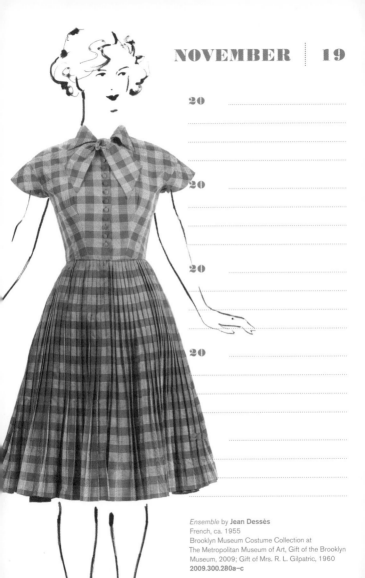

20

20

20

20

Ensemble by **Jean Dessès**
French, ca. 1955
Brooklyn Museum Costume Collection at
The Metropolitan Museum of Art, Gift of the Brooklyn
Museum, 2009; Gift of Mrs. R. L. Gilpatric, 1960
2009.300.280a–c

20

20

20

20

20

Suit by **Charles James**
American, 1948
Brooklyn Museum Costume Collection at
The Metropolitan Museum of Art, Gift of the Brooklyn
Museum, 2009; Gift of Arturo and Paul Peralta-Ramos, 1955
2009.300.199a–d

20

20

20

20

20

Evening shoes by **Roger Vivier**
HOUSE OF DIOR
French, 1957
Gift of Valerian Stux-Rybar, 1979
1979.472.23a, b

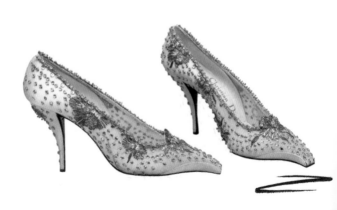

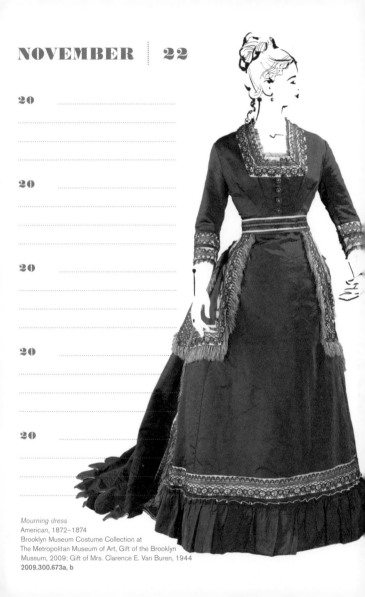

20

20

20

20

20

Mourning dress
American, 1872–1874
Brooklyn Museum Costume Collection at
The Metropolitan Museum of Art, Gift of the Brooklyn
Museum, 2009; Gift of Mrs. Clarence E. Van Buren, 1944
2009.300.673a, b

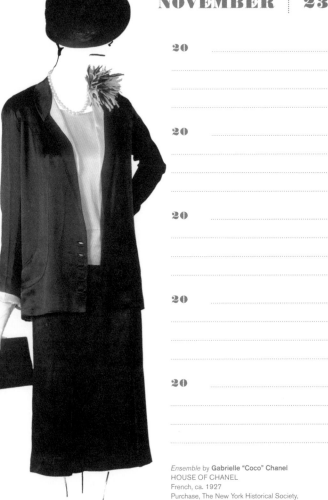

20
......................................
......................................
......................................

20
......................................
......................................
......................................

20
......................................
......................................
......................................

20
......................................
......................................
......................................

20
......................................
......................................
......................................

Ensemble by **Gabrielle "Coco" Chanel**
HOUSE OF CHANEL
French, ca. 1927
Purchase, The New York Historical Society,
by exchange, 1984
1984.29a–c

NOVEMBER | 24

20

20

20

20

20

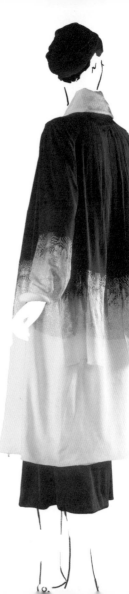

Coat by **Gabrielle "Coco" Chanel**
HOUSE OF CHANEL
French, ca. 1927
Purchase, Irene Lewisohn Bequest and Catharine Breyer
Van Bomel Foundation, Hoechst Fiber Industries, in honor
of Diana Vreeland, and Chauncy Stillman Gifts, 1984
1984.30

20 ..

20 ..

20 ..

20 ..

20 ..

Evening shoes
DELMAN
American, 1935
Brooklyn Museum Costume Collection at
The Metropolitan Museum of Art, Gift of the Brooklyn
Museum, 2009; Gift of Herman Delman, 1955
2009.300.1207a, b

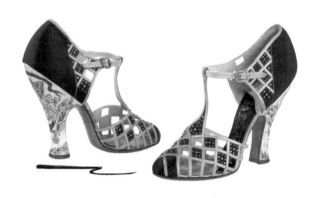

NOVEMBER | 26

20

20

20

20

20

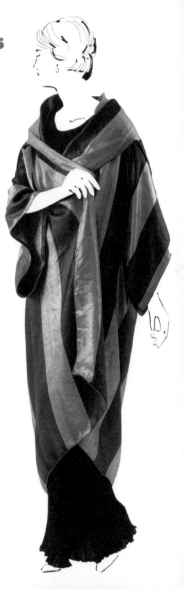

20

20

20

20

20

"Bar" by **Christian Dior**
HOUSE OF DIOR
French, Spring/summer 1947
Gift of Mrs. John Chambers Hughes, 1958
C.I.58.34.30

20

...

...

20

...

...

20

...

...

20

...

...

20

...

...

...

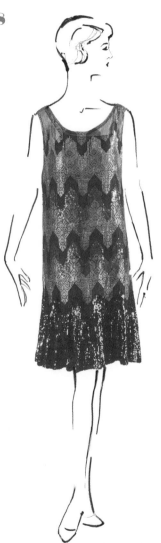

Evening dress attributed to **Gabrielle "Coco" Chanel**
HOUSE OF CHANEL
French, 1926–1927
Gift of Mrs. Georges Gudefin, in memory of
Mrs. Clarence Herter, 1965
C.I.65.47.2a, b

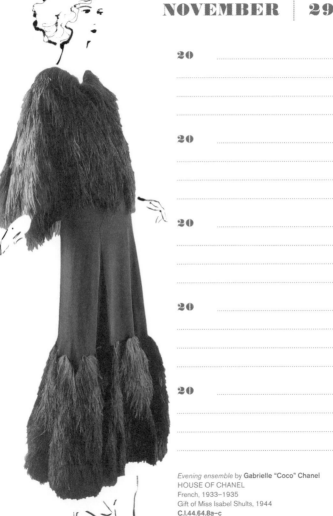

20

20

20

20

20

Evening ensemble by **Gabrielle "Coco" Chanel**
HOUSE OF CHANEL
French, 1933–1935
Gift of Miss Isabel Shults, 1944
C.I.44.64.8a–c

NOVEMBER | 30

20

...................................

...................................

...................................

20

...................................

...................................

...................................

20

...................................

...................................

...................................

20

...................................

...................................

...................................

20

...................................

...................................

...................................

Cocktail dress by **Charles James**
American, 1952
Brooklyn Museum Costume Collection at
The Metropolitan Museum of Art, Gift of the Brooklyn
Museum, 2009; Gift of Muriel Bultman Francis, 1966
2009.300.409

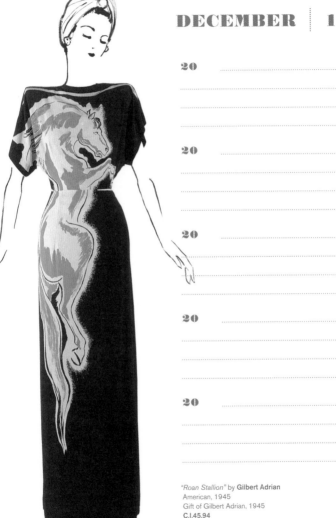

20 ...
...
...

20 ...
...
...

20 ...
...
...

20 ...
...
...

20 ...
...
...

"Roan Stallion" by **Gilbert Adrian**
American, 1945
Gift of Gilbert Adrian, 1945
C.I.45.94

DECEMBER | 2

20 ..

20 ..

20 ..

20 ..

20 ..

"Ponytail Boot" by **Adelle Lutz**
American, 2002
Purchase, Judith and Gerson Leiber Fund, 2003
2003.53a, b

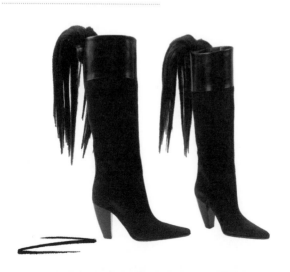

20

20

20

20

20

Parasol
Probably French, 1885–1895
Brooklyn Museum Costume Collection at
The Metropolitan Museum of Art, Gift of the Brooklyn
Museum, 2009; Gift of Gertrude Espenschied, 1940
2009.300.3020

DECEMBER | 4

20

20

20

20

20

Cocktail dress by **Cristobal Balenciaga**
HOUSE OF BALENCIAGA
French, 1962
Gift of Rosamond Bernier, 1994
1994.147.3

DECEMBER | 5

20

.......................................

.......................................

.......................................

20

.......................................

.......................................

.......................................

20

.......................................

.......................................

.......................................

20

.......................................

.......................................

.......................................

20

.......................................

.......................................

.......................................

Dinner dress by **Jo Copeland**
American, 1945
Brooklyn Museum Costume Collection at
The Metropolitan Museum of Art, Gift of the Brooklyn
Museum, 2009; Gift of Mrs. V. D. Crisp, 1963
2009.300.324

DECEMBER | 6

20 ..

20 ..

20 ..

20 ..

20 ..

Hat by **Mme. Mantel**
French, ca. 1885
Brooklyn Museum Costume Collection at
The Metropolitan Museum of Art, Gift of
the Brooklyn Museum, 2009; Gift of the Princess
Viggo in accordance with the wishes of the Misses
Hewitt, 1931
2009.300.1415

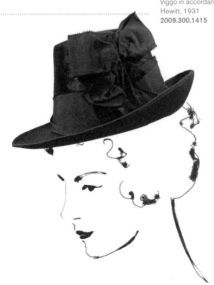

20
........................
........................
........................

20
........................
........................
........................

20
........................
........................
........................

20
........................
........................
........................

20
........................
........................
........................

Evening dress
MYRBOR
French, 1924
Brooklyn Museum Costume Collection at
The Metropolitan Museum of Art, Gift of the Brooklyn
Museum, 2009; Gift of Mrs. V. D. Crisp, 1963
2009.300.3248

DECEMBER | 8

20

20

20

20

20

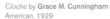
Cloche by **Grace M. Cunningham**
American, 1929
Brooklyn Museum Costume Collection at
The Metropolitan Museum of Art, Gift of the Brooklyn
Museum, 2009; Gift of Mrs. Albert Ogden in memory
of Sheldon Stewart, 1964
2009.300.2040

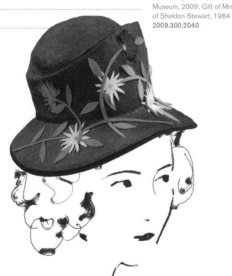

20

20

20

20

20

Parasol
TIFFANY & CO.
American, 1908
Brooklyn Museum Costume Collection at
The Metropolitan Museum of Art, Gift of the Brooklyn
Museum, 2009; Gift of the trustees of Mary Flagler
Cary Charitable Trust, 1969
2009.300.2589

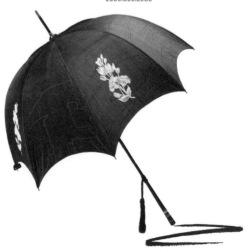

20

20

20

20

20

Evening sandals by **Salvatore Ferragamo**
Italian, 1938
Brooklyn Museum Costume Collection at
The Metropolitan Museum of Art, Gift of the Brooklyn
Museum, 2009; Gift of Brooklyn Museum Fair, 1956
2009.300.1505a, b

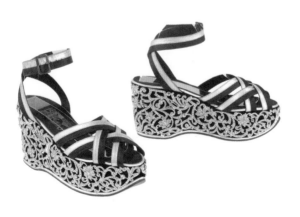

20

20

20

20

20

Dress
DRÉCOLL
French, ca. 1924
Gift of Mrs. Carter Marshall Braxton, 1980
1980.92.1a–c

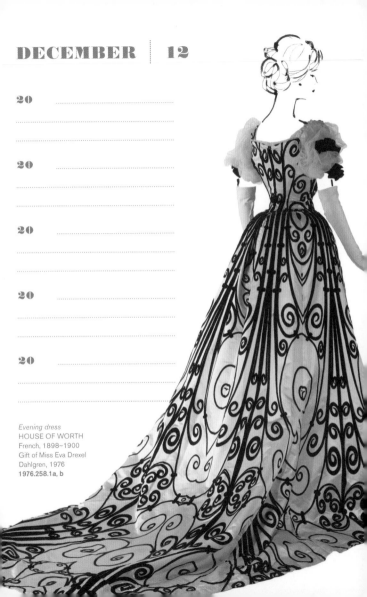

DECEMBER | 12

20

20

20

20

20

Evening dress
HOUSE OF WORTH
French, 1898–1900
Gift of Miss Eva Drexel
Dahlgren, 1976
1976.258.1a, b

20

20

20

20

20

Hat
American, ca. 1965
Brooklyn Museum Costume Collection at
The Metropolitan Museum of Art, Gift of the Brooklyn
Museum, 2009; Brooklyn Museum Collection
2009.300.2248

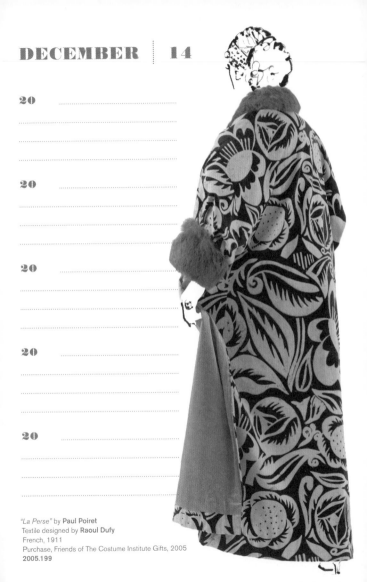

DECEMBER | 14

20

...

...

...

20

...

...

...

20

...

...

...

20

...

...

...

20

...

...

...

...

"La Perse" by **Paul Poiret**
Textile designed by **Raoul Dufy**
French, 1911
Purchase, Friends of The Costume Institute Gifts, 2005
2005.199

20

20

20

20

20

Cocktail hat by **Cristobal Balenciaga**
HOUSE OF BALENCIAGA
French, ca. 1966
Brooklyn Museum Costume Collection at
The Metropolitan Museum of Art, Gift of
the Brooklyn Museum, 2009; Gift of Mrs.
Benjamin R. Kittredge, 1971
2009.300.2600

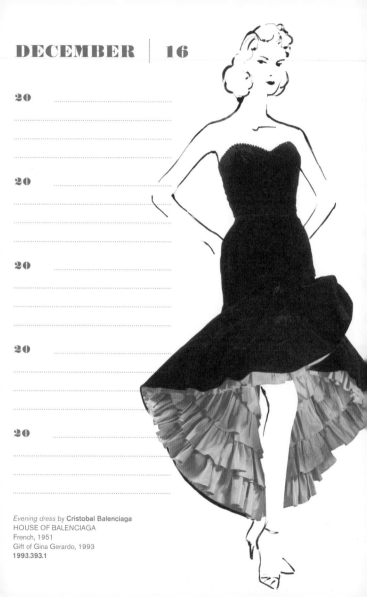

DECEMBER | 16

20

20

20

20

20

Evening dress by **Cristobal Balenciaga**
HOUSE OF BALENCIAGA
French, 1951
Gift of Gina Gerardo, 1993
1993.393.1

20 ... 20 ...

... ...

... ...

... ...

20 ... 20 ...

... ...

... ...

... ...

20 ...

...

...

...

Dinner toque
American, ca. 1912
Brooklyn Museum Costume Collection at
The Metropolitan Museum of Art, Gift of the Brooklyn
Museum, 2009; Gift of Helen Ray in memory of Mr.
and Mrs. William Ray and Miss M. Ray, 1951
2009.300.1842

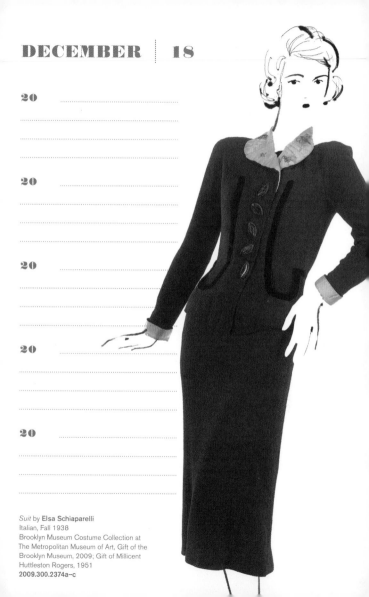

DECEMBER | 18

20

20

20

20

20

Suit by **Elsa Schiaparelli**
Italian, Fall 1938
Brooklyn Museum Costume Collection at
The Metropolitan Museum of Art, Gift of the
Brooklyn Museum, 2009; Gift of Millicent
Huttleston Rogers, 1951
2009.300.2374a–c

20

...

...

...

...

20

...

...

...

...

20

...

...

...

...

20

...

...

...

...

20

...

...

...

...

Pumps
DERIGÙ
Italian, 1955
Brooklyn Museum Costume Collection at
The Metropolitan Museum of Art, Gift of the Brooklyn
Museum, 2009; Gift of Charline Osgood, 1960
2009.300.3213a, b

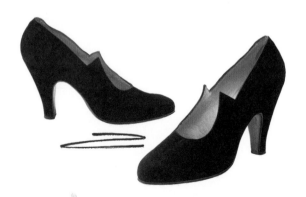

20

20

20

20

20

Dress by **Roselle Davis**
Textile designed by **Stuart Davis**
American, ca. 1938
Brooklyn Museum Costume Collection at
The Metropolitan Museum of Art, Gift of the Brooklyn
Museum, 2009; Gift of Mrs. Stuart Davis, 1976
2009.300.519

DECEMBER | 21

20 ..
..
..

20 ..
..
..

20 ..
..
..

20 ..
..
..

20 ..
..
..

Evening ensemble by **Gabrielle "Coco" Chanel**
HOUSE OF CHANEL
French, Fall/winter 1938–1939
Gift of Mrs. Harrison Williams, Lady Mendl,
and Mrs. Ector Munn, 1946
C.I.46.4.7a–c

20

...

...

...

20

...

...

...

20

...

...

...

20

...

...

...

20

...

...

...

"Cyclone" by **Jeanne Lanvin**
HOUSE OF LANVIN
French, 1939
Gift of Mrs. Harrison Williams, Lady Mendl,
and Mrs. Ector Munn, 1946
C.I.46.4.18a, b

20

20

20

20

20

Evening dress by **Cristobal Balenciaga**
HOUSE OF BALENCIAGA
French, Fall/winter 1965–1966
Gift of Diana Vreeland, 1973
1973.20

DECEMBER | 24

20 ..

..

..

..

20 ..

..

..

..

20 ..

..

..

..

20 ..

..

..

..

20 ..

..

..

..

Ensemble by **Christian Dior**
HOUSE OF DIOR
French, Spring/summer 1955
Gift of Christian Dior, 1955
C.I.55.63a–d

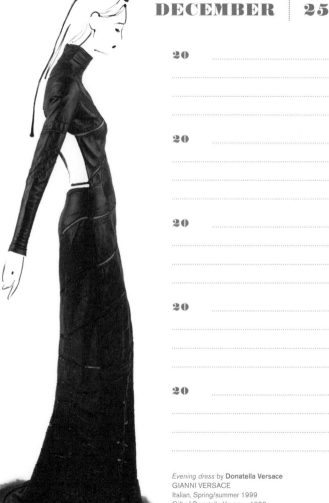

DECEMBER | 25

20

20

20

20

20

Evening dress by **Donatella Versace**
GIANNI VERSACE
Italian, Spring/summer 1999
Gift of Donatella Versace, 1999
1999.137.2

DECEMBER | 26

20
...................
...................

20
...................
...................

20
...................
...................

20
...................
...................

20
...................
...................

Evening dress by **Christian Dior**
HOUSE OF DIOR
French, Fall/winter 1949–1950
Gift of Rosamond Bernier, 1989
1989.130.1a, b

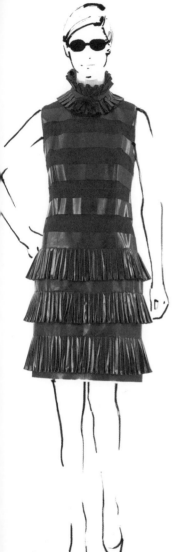

20

...........................

...........................

...........................

...........................

20

...........................

...........................

...........................

...........................

20

...........................

...........................

...........................

...........................

20

...........................

...........................

...........................

...........................

20

...........................

...........................

...........................

...........................

Dress by **Karl Lagerfeld**
HOUSE OF CHANEL
French, Fall/winter 1987–1988
Gift of Thomas Shoemaker, in memory of Michael L.
Cipriano, 1994
1994.161.1

DECEMBER | 28

20

20

20

20

20

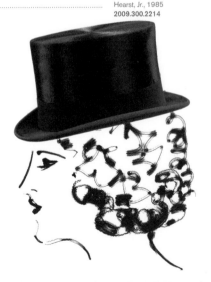

Riding hat
JAMES LOCK & CO. LTD
British, ca. 1930
Brooklyn Museum Costume Collection at
The Metropolitan Museum of Art, Gift of the Brooklyn
Museum, 2009; Gift of Mrs. William Randolph
Hearst, Jr., 1985
2009.300.2214

DECEMBER | 29

20

20

20

20

20

Evening dress by **Madeleine Vionnet**
French, 1936–1937
Gift of Madame Madeleine Vionnet, 1952
C.I.52.18.2

DECEMBER | 30

20
....................
....................

20
....................
....................

20
....................
....................

20
....................
....................

20
....................
....................

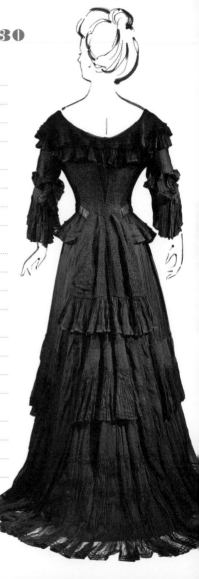

Mourning dress
American, 1902–1904
Gift of The New York Historical Society, 1979
1979.346.93a–c

20 ..

..

..

..

20 ..

..

..

..

20 ..

..

..

..

20 ..

..

..

..

20 ..

..

..

..

Evening ensemble by **Gabrielle "Coco" Chanel**
HOUSE OF CHANEL
French, 1937–1938
Gift of Yann Weymouth, 1981
1981.348.2a, b